Praise for *Tattoo Monologues*

———◆◆———

"After reading this book and reflecting on my own initial beliefs about tattoos, I am curious and intrigued. This book is transformative. Not only does it provide trauma survivors with the opportunity to verbalize the previously unspeakable, it also provides the reader with the opportunity to bear witness to another person's pain and triumph."

—**Sandra Bloom, MD**

"*Tattoo Monologues* sends a powerful message to tattooed trauma survivors like me. We don't have to cower in the shame of our trauma. We don't have to hide our ink. They are a part of our story."

—**Meagan D Corrado, DSW**

"The tattoo can be like writing a book telling one's life story and inviting others to notice and inquire. Sharing and connecting with caring individuals plays the most vital instrument in healing from a painful, challenging, or traumatic event."

—**Roy Wade, MD**

"Twenty-seven real stories from courageous women, holding on to life through the bold markings they wear on their bodies."

—**Gail Drucker, playwright**

Tattoo Monologues

Tattoo Monologues

Indelible Marks on the
Body and Soul

Donna L. Torrisi, MSN and John Giugliano, Ph.D., Authors
Ken Kauffman, Photographer

SHE WRITES PRESS

Published 2021
Printed in Canada
Print ISBN: 978-1-64742-311-7
E-ISBN: 978-1-64742-312-4
Library of Congress Control Number: 9781647423117

Interior design by Tabitha Lahr

For information, address:
She Writes Press
1569 Solano Ave #546
Berkeley, CA 94707

"Photography is a small voice, at best,
but sometimes one photograph, or a group of them,
can lure our sense of awareness. "

—W. Eugene Smith

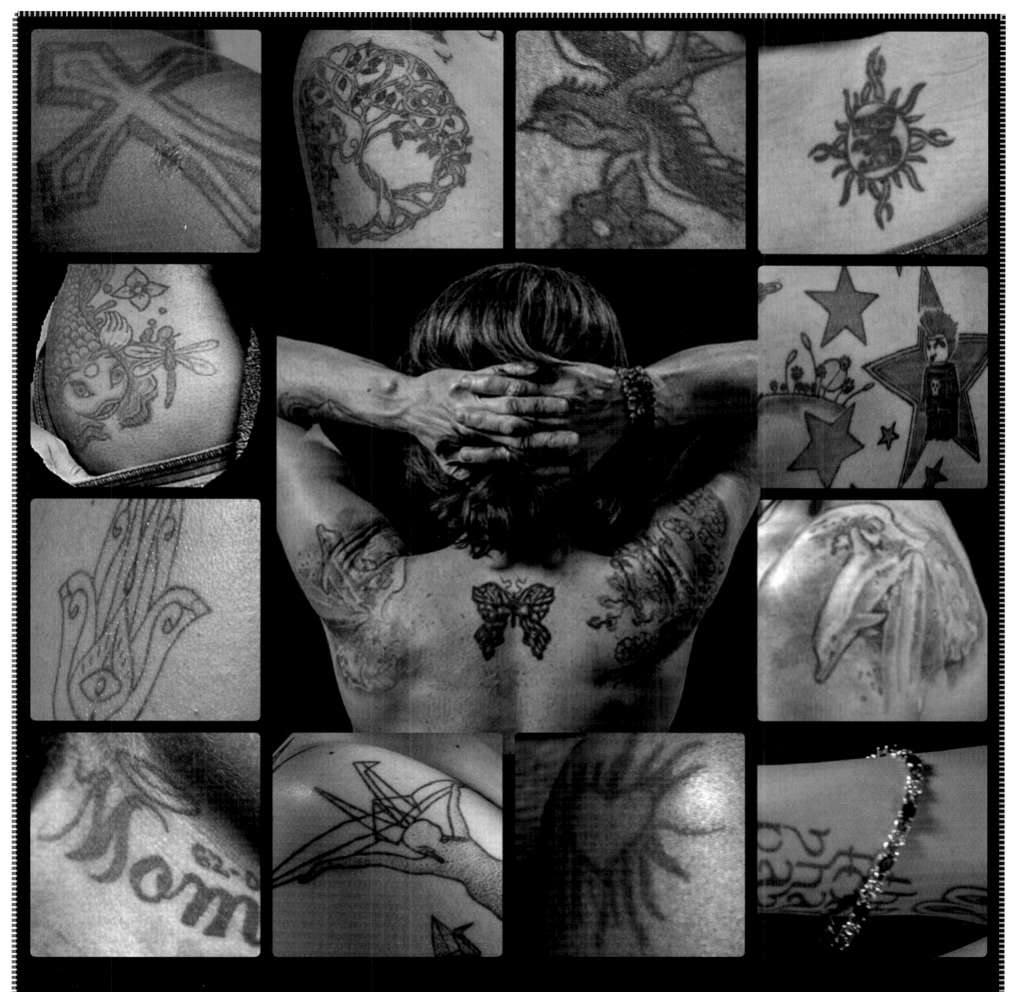

" *...up from a past that's rooted in pain I rise...* "

—Maya Angelou

——— ◆ ———

In gratitude to all the courageous and generous women
who told their heartfelt stories. It was truly a gift to
bear witness to the deepest parts of your lives.

Contents

Foreword. .14

Engagement. .19

Proclamation .20

Stories

1. Against All Odds. 23

2. Betrayal . 25

3. Sick of my shit.29

4. Dejection. .31

5. Paper Cranes .35

6. Lego Man. 38

7. Reclaimed .41

8. The Gift . 44

9. Guardian Angel 47

10. Gemini . 49

11. Recovering . 52

12. Rescued. .55

13. Muck and Mire. 57

14. She's Got My Back 59

15. The Slide. **62**

16. Hope in a Dragonfly **65**

17. Forgiveness . **68**

18. Pink Dress . **71**

19. Tic Tac. **73**

20. A Nice Ass . **76**

21. Motherless . **79**

22. Huey, Dewey, and Louie **81**

23. La Belle La Vie . **85**

24. Protection . **87**

25. A Daisy Moment. **89**

26. Abandoned . **93**

27. Baring My Chest. **95**

28. Engraved on God's Hands. **99**

29. Teardrops . **101**

Reference . **103**

Author's Reflections and About the

 Authors/Photographer **104**

Foreword:

Scars of Ink

⸻ ◆ ⸻

By Sandra L. Bloom, MD and Meagan D. Corrado, DSW

Personal Reflections: Sandra Bloom

I have never been tattooed. Fortunately, (or unfortunately), I have never had an experience so compelling that I permanently etched a reminder of it on my skin. My own initial hesitance to write this foreword stemmed from my own doubts about whether I had anything of value to say. Sure, I could write about trauma and its effects, but what could I say about wounds that people inflict on their own bodies? What could I say about these painfully acquired words and symbols? In preparation for this foreword, I asked a few of my younger friends about tattoos. Their enthusiastic, eager responses starkly contrasted my own disconnection. As a bystander, I have watched tattooing increase in popularity throughout the past few decades. In writing this piece, I took a moment to reflect on the experiences that impacted my original perspective on tattoos.

I am from a generation that connects tattoos to drunken sailors, motorcycle gangs, prison inmates, and survivors of the Holocaust. My mother was raised as a Quaker. Although I can't recall her directly talking about tattoos, I somehow know that she would not approve. Her disapproval would not have been motivated by religion as much as by class.

Class was very important to my mother, presumably because of her own experiences. My mother, who lived until she was ninety, said that she had no good memories of her childhood. When she was young, her father abandoned her and her mother to start another family. Although her father was an accountant, he provided little support. As a divorced woman in the 1920s, my grandmother sold washing machines to provide for the family. As far as my mother was concerned, the family had "come down in the world." I suspect that they were poorer than I ever realized. The experience of shame, and her defenses against it, dominated my mother's existence. She cared deeply about what other people thought about her. She also cared about what others thought of me.

My father was an easygoing man who lived until he was 102. Although he was also from a broken home, he seemed to have only good memories of his childhood. He was far less judgmental than my mother, but he probably had an unfavorable view of tattoos too. These associations were characteristic of my parents' generation, relegating tattoos to people who are poor, defiant, or rebellious. These familial attitudes, and the negative connotation tattoos have had in my own generational context prevented me from ever considering one.

A BRIEF HISTORY

Tattooing has always existed in one form or another. Ancient Egyptian and Peruvian mummies bear evidence of tattooing practices. When archeologists uncovered a Siberian burial ground from 5 BCE, they found intricate line markings adorning the arms, legs, and torsos of the nomadic community. North American indigenous people used tattoos to affirm tribal affiliations and to memorialize key life events (Wallace 2013).

Historically, tattoos have played a controversial role in Western society. During Constantine's rule over the Roman Empire, tattoos were banned (Reyntjens 2001). They re-emerged under the Anglo-Saxons when nobility used tattoos to signify religious or personal devotion. In fact, the only way that King Harold was identified at the Battle of Hastings was because he had "Edith," his wife's name, tattooed over his heart. Western tattooing was banned by the Catholic Church in the 8th, 9th, and 10th centuries, but during the Crusades, religious tattooing became commonplace.

In the 1800s, tattooing grew in prominence among the wealthy. The tattoo machine had not yet been invented, and the Polynesian process that the West adopted was both tedious and costly (DeMello 2000). While tattoos were being used as a status symbol for the wealthy, slaves and prisoners were being forcibly branded throughout the world (Morgan & Rushton 2005). In 1891, with the invention of the electric tattoo machine, tattooing became more accessible, and the process was quicker and less painful. In World Wars I and II, tattoos became increasingly popular among veterans as they used them to symbolize important relationships, years of service, and the lives of fallen soldiers (Littell 2003). Simultaneously, tattoos were used as weapons of oppression, branded on Jewish people residing in Nazi concentration camps. Primo Levi, an Italian Jewish chemist, author, and Holocaust survivor, describes tattooing as part of the dehumanization process.

Throughout the 20th century, tattoos continued to grow in popularity throughout America due to their speed and cheaper cost (DeMello 2000). Tattoo parlors became a gathering place for "sailors, carnies, drunks, laborers, as well as younger boys who hoped to learn the trade" (DeMello 2000, 59-60). At the same time, sterilization posed significant health concerns. Many states throughout the country banned tattoos due to their role in spreading disease. Tattoo artist Lyle Tuttle played a significant role in implementing sterilization practices and increasing professionalism (DeMello 2000). With the introduction of sterilization practices, and the increasing notoriety of the profession, tattooing became safer. Greater design options became available to customers.

Today, Americans spend $1.65 billion a year on tattoos. The tattooing industry accrues $2.3 billion annually in the United States alone (Kennedy 2010). According to present sources, 36% of Americans between the ages of 18 and 29 have at least one tattoo, and 21% of Americans (approximately 45 million people) have one or more tattoos. There are more than 20,000 tattoo parlors nationwide, with a new tattoo shop being opened every day (History of Tattoos 2019).

Although societal perspectives on tattooing have evolved, there is still some controversy surrounding this practice. Some theorists suggest that tattooing is indicative of psychological and characterological deficiencies, immaturity, and anti-social tendencies (Taylor 1970). Others suggest that tattooed individuals use body art as a cover-up for characterological flaws and poor self-esteem (Sanders & Vail 2008). Theorists with a more favorable view of tattoos speak to their symbolic and narrative meaning.

THE BODY AS A CANVAS

Cultural idioms speak to the connection between our skin, sense of touch, and relationships with self/others. Thin-skinned people are said to be especially sensitive, while thick-skinned people are considered tough. Those who are tactless or blockheaded "get under our skin," while people who are prone to anger are "touchy." We can "rub people the wrong way." Some people need a "soft touch," while others must be "handled carefully." The linguistic connection between skin, touch, and relationships is not limited to English; many languages express this interconnectedness.

In tattooing, the individual uses their own skin as the artistic foundation. The body itself is the canvas. Unlike traditional artistic mediums, in which individuals create images on an external surface, tattooing requires the use of one's being. The tattooed

skin becomes a nonverbal, symbolic form of communication with the self and with others.

"Although it may sound strange, or unnatural, to think of a person's body, namely their skin, as a canvas, it is important to point out that people have used their bodies as conduits for communication since infancy. Physical communication, devoid of language but pregnant with meaning, is ingrained in human beings in the first moments of life. Before children even utter their first words, they use their bodies to communicate with the world. Our first language is an enacted language, best captured in gestures, music, dance, and mime. We continue to use non-verbal forms of communication throughout the lifespan.

Sometimes language falls short and words don't have the power to convey the depth of our experiences. When we cannot find the words to describe life's most powerful moments, our bodies speak for us. As articulated by the early psychoanalyst, Georg Groddeck, "When something has to be communicated from the innermost soul . . . then it is done by gesture, touch, by the light of the eyes, perhaps even by music, but never by language. The barrier is insurmountable" (Groddeck 1977, 279).

TATTOOS AND TRAUMA

How do tattoos relate to trauma? Trauma leaves sudden, irrevocable marks on the brain, body, mind, and spirit. These permanent traumatic imprints create a profound sense of loneliness. They cause the trauma survivor to feel detached and alienated from themselves and from others. They shatter the individual's fundamental understanding of safety. They leave the person feeling out of control as thoughts, feelings, and memories chaotically intermingle with one another. The mark, the tattooed imprint that the trauma leaves on the brain is referred to by one author as a "quantum transformation" (Fosha 2006). Everything changes in an instant, and this change is not linear or progressive: it is earth-shattering and jarring.

Trauma theory is the science of suffering. This suffering can be experienced as a single event or a series of traumatic moments. Because the brain is overwhelmed, normal integrative functioning ceases. During the trauma, the mind dissociates, separating traumatic images, sensations, and emotions from the ongoing biographical narratives that help us make sense of ourselves and the world. It is in the nonverbal unconscious, the right hemisphere, where the traumatic memories are stored, separated from the language to describe them or the context to make sense of them.

Best practices in trauma treatment advocate for trauma survivors' development of an integrated trauma narrative. But how do you make meaning of experiences buried in the unconscious recesses of the right hemisphere? How do you integrate the pieces of your narrative that are disconnected from language? How do you verbalize and make sense of the parts of your story that are so painful that words cannot describe them?

Symbols, or mimetic representations, fill the gaps when trauma leaves a mark so impactful that words are elusive. From dance and music to collage and tattoos, symbolic representations of our experiences allow us to access the traumatic memories buried so deeply in the brain that we don't have the words to describe them. And after we have accessed these memories, we can reclaim control over our narratives and make meaning of our experiences.

Tattoos represent a personal and public attempt at symbolically capturing pieces of an individual's narrative, and unlike the disconnected scars left behind by trauma, tattoos leave behind "Scars filled with ink" (Fruh & Thomas 2012, 87), and "whatever their content, however unique or generic, however badly or well inked, however their stories are told (truthfully or as complete fabrications), tattoos tell a story about a person's relationship with their body and their relationship with the world" (Lee 2012, 156).

For trauma survivors who experience a sense of powerlessness, the tattooing process provides an opportunity to regain mastery and control. Although the person had no control over the trauma, and its subsequent effects, they have agency over the symbols they choose to have tattooed. An inmate stated of the sense of power his tattoos gave him during imprisonment: "In life, someone can take everything we have: our clothes, home, and family. They can make us lose our pride, our minds, and our will power. They can lock us up. But these tattoos are mine. They will have to skin me to get them" (Sarnecki 2001, 39).

I have spent the past thirty years studying trauma. I have seen its destructive impact on my patients. I have also witnessed their creativity and ingenuity. I have come to respect the intertwined nature of these two concepts: creation and destruction. As you read *Tattoo Monologues*, you will discover examples of the many ways that people transform trauma into creativity, using their personal "parchment" to express feelings and experiences. For many, the marks on their bodies help them memorialize lost loved ones, remind them of lessons learned, serve as mindfulness and memory tools, and help them to self-soothe. For some, tattooing is a way to reclaim control and a sense of personal power after profound experiences of unutterable helplessness. For others, the pain inflicted as part of the tattooing process provides a cathartic release of painful emotions and memories, a ritual passage into another way of being.

After reading this book and reflecting on my own initial beliefs about tattoos, I am curious and intrigued.

This book is transformative. Not only does it provide trauma survivors with the opportunity to verbalize the previously unspeakable, but it provides the reader with the opportunity to bear witness to another person's pain and triumph. Although I have no plans on tattooing my weathered body, *Tattoo Monologues* fostered a new appreciation and understanding for tattooing, demonstrating that we are never too old to change.

Sandra Bloom MD, Dornsife School of Public Health, Drexel University, Philadelphia, PA

Personal Reflections: Meagan Corrado

People have tattooed memories, identities, and affiliations on their bodies throughout the course of human existence, from ancient Egyptians to American cultural icons. Tattoos, although increasingly common, have aroused intergenerational conflict and cultural contention. How do you feel about tattoos? Some of you may find this question archaic and obsolete. Others may find it contentious and polarizing. Your response will undoubtedly be shaped by culture, generational context, religious beliefs, environment, and experiences.

Tucked away in the biblical book of Leviticus there lies a single verse about tattoos. "You shall not make any cuts in your body for the dead nor make any tattoo marks on yourselves. I am the Lord." (Leviticus 12:28). Growing up in the church, I was taught that tattoos are a sin, a permanent blemish on the pure, untarnished body God has given me. But, internally, I questioned this. My mind and my body didn't feel "pure and untarnished"—not after the trauma I had endured, and sin seemed like such a strong word for something so artistic and colorful.

At the age of 20, I walked into a tattoo shop on Philadelphia's famous South Street. The distinct buzz of electric needles reverberated through the space. I talked to the artist about my idea. To me, the concept was revolutionary: a tattooed key with a heart in the center. It would be two inches long and half an inch wide. I wanted it placed behind my left ear.

The artist poured ink into a small plastic cup, removed a clean needle from a sealed package, and turned on the tattoo machine. The incessant buzzing instantly provoked fear, excitement, and anticipation. He pressed the needle into my skin. It hurt. But I knew that after the pain had subsided, a symbolic piece of my narrative would be left behind, and this symbol would forever be a part of me.

This symbol as well as others that I later had tattooed on my body meant something to me. They contributed to my sense of safety. Despite the instability, turmoil, and abandonment I have experienced, my tattoos are always with me. They represent mastery and ownership. I had the agency to choose images that captured the strength and adversity in

my narrative. They fill me with a sense of pride. Not only did I survive the pain, but I have found beauty on the other side.

My tattoos also represent a transformative experience with pain. Unlike the pain I endured during traumatic life events, the pain of tattooing was self-selected, and goal directed. The pain was not an end in itself, but rather the pain was a conduit for creative expression. Although the process hurt, something happened *after* the pain, the wounded skin healed, and on the other side of the pain, there was beauty.

Depending on your cultural, generational, or environmental context, you may have made certain assumptions about my race, professional affiliation, and education as you read my reflections. Despite the growing number of tattooed people throughout the nation, many of us still hold deeply ingrained beliefs about what it means to be tattooed. I want to challenge your assumptions—not only your assumptions about me, but about other tattooed trauma survivors.

I am not a deviant reprobate. I am an educated, articulate African American woman. I am an Ivy League graduate. I am a doctor of social work, a graduate professor, a trauma therapist. My tattoos are not permanent blemishes on a "pure, untarnished body." They are symbols of my strength. They are pieces of my story.

Throughout my career as a trauma therapist, I have seen many tattoos. I have seen impulsive tattoos and meticulously planned ones. I have seen tattoos memorializing life and tattoos commemorating death, tattoos shared with pride and tattoos hidden in shame. Of the hundreds (maybe thousands) of tattoos I have seen, I have never come across one that was not somehow connected to a person's narrative.

Tattoo Monologues sends a powerful message to tattooed trauma survivors like me. We don't have to cower in the shame of our trauma. We don't have to hide our ink. They are a part of our story.

The collective voices of the women featured in this book present an alternative narrative about tattoos. Tattoos are not only for sailors and slaves. They are not only for gang members and bikers and social outcasts. They are also for social workers, teachers, and students. They are for accountants, medical professionals, and homemakers. They are for artists, therapists, and lawyers.

Despite the controversial history of tattoos, *Tattoo Monologues* offers an alternative frame for understanding and appreciating not only their symbolism, but the narratives that inspire them. This book suggests that we can reclaim a medium shrouded in stigma. We can rewrite the narrative. Isn't that what trauma healing is all about: reclaiming that which was lost, transforming the pain, making meaning, and regaining control?

The women featured in *Tattoo Monologues* demonstrate vulnerability and courage as they share their personal tattoo narratives. These women represent diverse cultures, ethnicities, and professional contexts, but they are united by their use of tattoos as a tool for processing traumatic life experiences. The images, stories, emotions, and experiences in this book collectively tell a compelling story.

A story of skin and ink.
A story of trauma and adversity.
A story of courage and resilience.

Meagan Corrado DSW,
Stories Trauma Narratives, LLC, Philadelphia, PA
Photo © Christopher Cook

Engagement

—————•—◆—•—————

Roy Wade, MD, Pediatrician, Trauma Researcher

We know a lot about health disparities based on the health care people receive, their genetics, and their health behaviors. What we are just beginning to understand is the relationship between health disparities and the trauma that individuals experience. New evidence indicates a relationship to health outcomes such as diabetes, heart disease, obesity, and substance abuse. Therefore, health care providers should screen for trauma.

Trauma screening can include noticing and asking about prominent or even more privately placed body art. These body markings facilitate conversation readily, and most people are willing to open up and talk about the story told by their tattoo. This can lead to the uncovering of a trauma history and presents an opportunity for the health care provider to be a conduit for more trauma-focused resources for the individual or family. This might help individuals lead a healthier life rather than adopt maladaptive behaviors, such as substance abuse or poor nutrition, or suffer from chronic anxiety or depression. Secondly, uncovering and having open discussions about an individual's difficult past has the capacity to change the relationship between patient and provider, creating more understanding, connection, and trust, which can lead to a healthy behavioral change.

It is not uncommon for me to notice a "Rest in Peace" tattoo on my adolescent patients. This is an opportunity for me to express curiosity, and I sometimes learn that a loved one, perhaps even a parent, has passed prematurely. By memorializing a loved one, or a difficult or traumatic event, in the form of body art, a new narrative can be created. Instead of self-blame, "I deserved it" or "I am a bad person," the story can change to: "Something bad happened to me that was beyond my control, and I can lead a healthy life without staying stuck in a fearful state." The tattoo can be like writing a book of one's life story and inviting others to notice and inquire. Sharing and connecting with caring individuals is the most vital instrument in healing from a painful, challenging, or traumatic event.

Delmina Henry, PhD

Proclamation

Interviews with Two Trauma Experts: Dr. Judith Stern and Dr. Delmina Henry

Interviewer: What is trauma and how does it differ from grief?

Dr. Judith Stern: Trauma is anything that happens to someone that is out of the ordinary, and results in feelings of prolonged fear and loss. It is something for which the individual is not prepared. Depression, anxiety, and hypervigilance may result. How a person responds to it influences whether it is perceived as a trauma.

Trauma, especially when occurring in childhood, may have a profound effect on the brain. The brain has a thinking part, the frontal cortex, and an emotional part, the limbic system/hippocampus. In very young children, there is an absence of strong connections between these two parts of the brain, so the brain is poorly integrated. With trauma, the thinking part of the brain is "offline," and the emotional part is flooded. This can result in an overwhelming experience far beyond an individual's capacity to cope. You might think of this part of the brain as a glass of water that is filled to 95 percent capacity. It can take very little for an event to flood the brain and elicit a strong emotional reaction that may seem out of place. This may be difficult for others to understand.

Early trauma can result in the loss of a healthy childhood. If trauma involves physical or sexual abuse in childhood, there is a veil of secrecy. A child often blames him or herself for the event. If a child becomes a "whistle blower," it can tear a family apart, children may be separated from their siblings, and all the children may be torn away from the parent or parental figure.

Judith Stern, PsyD

Interviewer: Is it possible for a person to heal from trauma?

Dr. Judith Stern: Healing can occur, but it takes time. Treatment is geared toward building connections between the thinking and feeling parts of the brain, while helping to quiet the brain's emotional part. Education may include help in self-soothing, so the person is not always in emotional overload, and reassurance that the trauma was not the fault of the individual being treated.

Interviewer: Have you experienced, with any of the people you treat, tattoos correlated to traumatic life experiences? And if so, what do you think is the significance of tattoos as they relate to trauma?

Dr. Delmina Henry: I have seen tears tattooed on the face, and names of people who have been lost to my clients tattooed on their body. Although in chat rooms and blogs you will find stories from people about their use of tattoos to help healing

from trauma, there really is a lack of literature in this area. So, my thoughts on this are only theories.

Dr. Judith Stern: Abusive experiences are often kept hushed in the family for a variety of reasons. A tattoo representing the trauma may be a way for the individual to say, "Hey, look at me," countering previously held secrets. The act of getting a tattoo I am told can be painful. Childhood abuse inflicts unwanted pain, both physically and emotionally. The tattoo/self-inflicted pain may be a way of taking control as the pain now is a choice.

Dr. Delmina Henry: Sometimes we encourage victims of trauma to engage in writing their history and experiences. In the case of the tattoo, writing and telling the story is done on one's own body. A little mark may carry a big story. So, a tattoo may represent some type of resolution for the trauma victim. The individual may be trying to make sense out of, and understand, what has happened to them. This is an interesting new area that we need to learn more about.

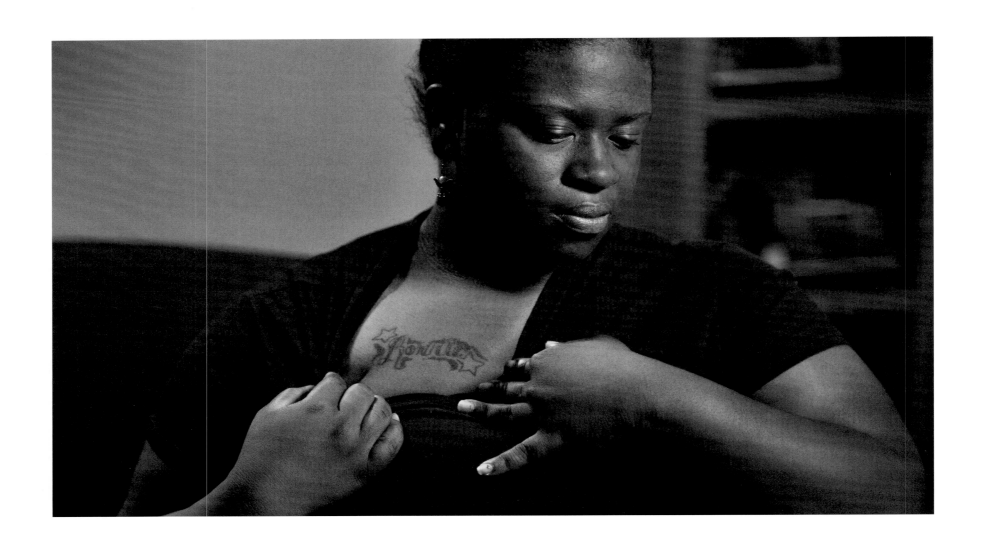

Against All Odds

Alicia Bradshaw, Age 19, Medical Assistant

"To all the motherless daughters out there; may your heartache serve you in the best of ways. May your grief give you a better understanding of yourself, may your sentiment allow you to express and create, and may your love expand beyond what you ever thought possible."

—Kayko Tamaki

Who thinks they are going to lose their mother at nine years old? My mom just keeled over in our home, and that was the end. There she lay on the floor, in total stillness, at the entrance to the bathroom. Alone and confused, I was horrified and frightened, and I was not sure where to turn. Eventually I called for help, and an ambulance came and took her away. It did not seem like my mother, my lifeline, could possibly be gone. I felt utterly alone and depressed after the loss of my mom. I miss her; talking about it brings up a lot of emotion and makes me cry. After she died, I was terribly lonely and didn't feel like anyone was there for me. I was her youngest child, and in reality, it was just me and my mother all my life. My older siblings all lived with relatives, so we were a twosome and really, she was my entire life.

My mother had a terrible history of childhood abuse, and she had a mental illness called Dissociative Identity Disorder. She struggled with being overweight and also developed diabetes. She spent a lot of time in the clinic to get help. She was lonely, too, and she often kept me out of school to keep her company. So, I too was a fixture in the health center, and the staff became my extended family, the clinic my second home. I am now nineteen and I continue to seek support from one of the health center's psychologists.

I wanted to have something permanent that would be a reminder of my mother. I got my first tattoo when I was sixteen. It is my mom's name, "Ronnie." Ronnie is now forever on my chest, near my heart. The tattoo helps me to know she is still there a little bit, though it is painful to know that she is not there in the way I desperately need her to be.

Because I don't have my mother, others may feel that I cannot make it in life. For that reason, I feel like I have to prove to myself, and to others, that I can be better than anyone thinks. I have achieved something big in succeeding in school and have defied odds in becoming a professional medical assistant. I live with my sister, brother-in-law, and dog. These relationships keep me going. I have a special bond with and love for my dog. He brings me such joy.

Someday I will have his paw print on me. When he jumps on me, squealing in doggie talk, it is as if he is saying he loves me. This brings such a smile to my face, especially when I am not having a good day.

My sister and I wanted something to bond us permanently, so we got matching tattoos with one another's lip prints on our arms. I already feel closer to her; this special connection is wonderful.

I am closer to my siblings since my mother passed. I did not know them much before that, as they weren't ever around. Closeness was missing in a way I imagine brothers and sisters should be. When my brother and sister are at odds, I feel sad because we all need each other. I just want everyone to be happy.

If somebody is thinking of getting their first tattoo, my advice is to get it where it won't hurt, and get something meaningful that matters, and something you won't regret. I will have my mom and my sister with me forever.

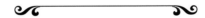

A daughter's loss of a mother can be an agonizing experience. There are many factors that will contribute to how that child will grieve. Where was the child developmentally when she lost her mom? What were the circumstances of the death? What was the type of relationship she had with her mother prior to the death? What kind of support was available during and after the death?

The mourning for a mother never really ends. A mother's love is unique and special; a mother provides a daughter with support and advice, and she serves as a role model that will influence a daughter's self-esteem, values, hopes, and attitudes. This is the mother that Alicia will hold in her heart and mind forever.

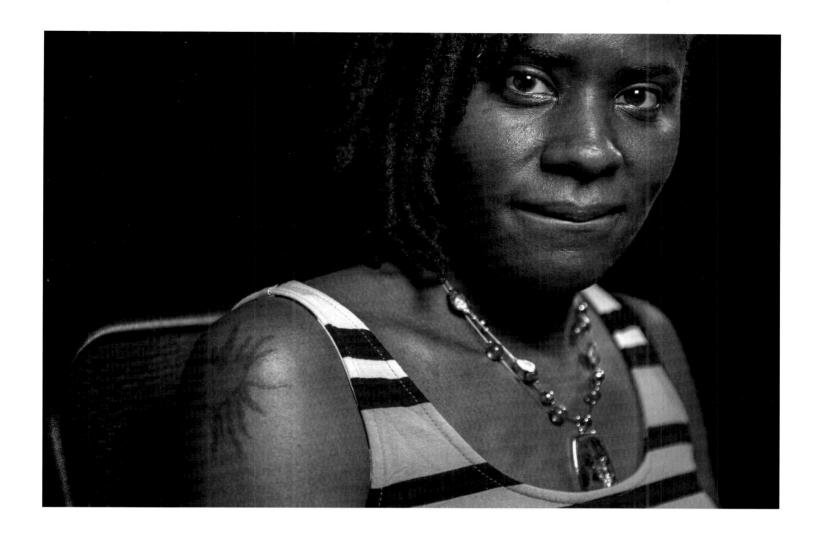

Betrayal

Annette Deigh, Age 38, Licensed Clinical Social Worker

"There comes a time in life, when you walk away from all the drama and people who create it. You surround yourself with people who make you laugh, forget the bad, and focus on the good. So, love the people who treat you right."

—Author Uknown

My younger sister called it the "House of Horror." Until I was twenty, I only knew abuse. My father abused my mother when she was pregnant and inflicted what we called PMS on us: Physical, Mental, and Sexual abuse. The beatings began when I was two; first hitting, punching, and then use of a belt. From age six to thirteen, I was raped. My mother took me to the doctor for birth control, and once I was even treated for an STD. I was so scared. I thought I would not be able to have children, but fortunately, I am now pregnant with my second child. My mother took us kids and tried to escape once, but the consequences were so severe when he found us in Texas that she never tried again. I still remember my mother's blood splattered on the wall from the beating.

School became an escape for me; I loved it and was a good student. My father punished me by keeping me out of school. Truancy should have been a red flag. Even the bruises

on my sister that led to a DHS (Department of Human Services) visit amounted to nothing. My father used to say, "Do not betray me."

I was saved by a school counselor who took me under her wing and helped me apply to college and get scholarships and financial aid. Interestingly, I majored in criminal justice, and planned to be a lawyer. Victims often grow up to be perpetrators, and at age twenty, when I pushed my mother, I was catapulted into doing something. This is not who I wanted to be; enough was enough.

With mixed feelings, and with an awareness that I was turning on the man who was supposed to be my protector, finally, I betrayed my father and told the family secret to the police in the 39th District of Philadelphia. My father was put away for ten years. My family was released from their prison and experienced a freedom we had never known. I needed to mark this huge turning point in my life. I am a person with a lot of heart, courage, and passion, so a heart encased in fire on my shoulder seemed fitting. When I look at it, a smile comes to my face.

For my own emotional healing, I had to go to therapy and work through the difficulties. I always wanted to help people and found my career in social work as a therapist working with individuals who, like me, lived with trauma. When I think it might be helpful, I disclose myself as a trauma survivor to my clients. It is actually cathartic for me to be helping others, and helpful for them that I can relate to their experience. I work on not getting restimulated by their stories by very mindfully practicing self-care, which includes writing poetry. I share with others that there is always "hope and a way out" of the pain.

Taken

You took so much from me
In so many ways
Some losses will always be there . . .
I feel them to this day.
You took my childhood.
My innocence.
And nearly my life.
But sitting here today,
I am no longer filled with the same levels
Of grief and strife.
You tried to take my person,
My being,
To fill it with shame.
You made sure that you were IN CONTROL.
You were winning the game.
You took so much from me.
And you tried your very best
To take parts of my future away.
So despite all of the positive strides,
I can still feel that to this day.
But guess what?!
Even though you took so much from me,
MY PRESENCE WILL BE HERE TO STAY!!!

Victims of trauma unconsciously figure out ways to survive. Not everyone can fight back or deny their terrible realities. Trauma is not always a single event; for some, it is complex and ongoing. Veiled in the appearance of normalcy, protected by the trap of silence, the fear of abuse is incessant. For some, there is no one to run to, no one to turn to, no one to tell. No one.

Efforts to escape or seek help are met with escalating consequences should silence be broken. There is no porthole for possibilities or to breach for passage to safety. Victims learn to accept helplessness or to be extinguished. Hiding in the safety of pain trumps the hopes of freedom. Things won't change, this is how it is. Annette tells about the dynamics of helplessness and hopefulness.

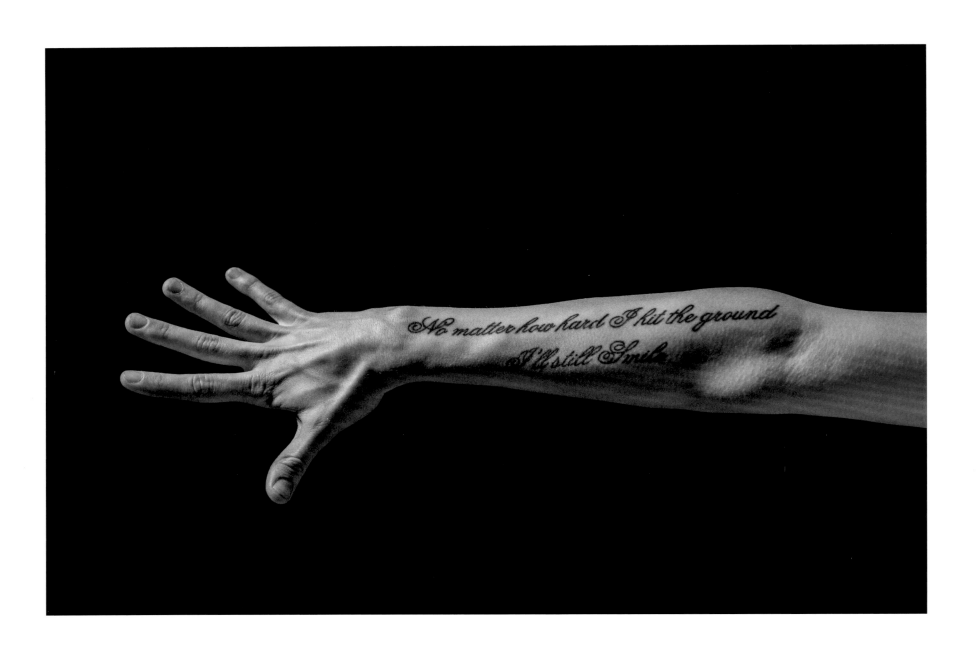

Sick of my shit

◆—◆—◆

Anonymous

"If we are facing in the right direction, all we have to do is keep on walking."
—ZEN PROVERB

"This too shall pass" on my arm covers the scars from the needle tracks, but more importantly, reminds me to let go when life throws shit at me. Life is a cycle, and nothing lasts forever except the love you give to each other and that resonates within all of us.

It started when I took Percocet following wisdom teeth extractions. In addition to a lot of fighting in my home when I was growing up, my father and sister both were addicted to drugs. My parents split. Heroine was cheaper and a better high, so that became my life for five years until last summer. I was in and out of relationships, living from one place to another. I lost everything, including my car. I thought I hit bottom when I began selling myself, but it only got crazier when my boyfriend asked me to break his arm so he could get drugs. I actually did it by standing on a table and jumping onto his arm. My spirit had hit bottom.

Shoplifting led to my arrest, and I was fortunate to get parole even though they found drugs on me. I violated it and was on the run for four months until I turned myself in and landed in jail. Even there it was easy to get drugs; the guys went out to work and brought them back, hiding them under the food on our trays. There were also ways to get drugs hidden in envelopes mailed from the outside.

Jail was horrible: a day felt like a month, I never saw the sun, and it felt never-ending. Here are some of the ways I survived: because they kept the light on all night, I made an eye blinder out of a sanitary pad and the string from tampons. Because I was a trained masseuse and I gave massages to the women, this helped me get along with everyone, and they brought me morning coffee and things from the commissary. For Thanksgiving, I made the other girls scrubs for the shower by combining sugar, coconut oil, and shampoo.

Though other friends and family were sick of my shit, my sister, whom I had helped get clean, stuck by me. She pulled me out of a lot of stuff and would put minutes on my phone. I prayed to my grandmother to get out by Christmas; still addicted, I got out on Christmas Eve. There was more detox and recovery to come, and eventually I landed in Kensington, a place where I still live, and hate, but I have been able to help a lot of girls. What I have learned is that a person could look like everything is fine, but you have no idea what is going on inside until you get close to their soul.

What is next for me is getting out of Kensington and working in my trained area as a phlebotomist. Hey, it sounds crazy but with plenty of experience sticking myself, I found

I'm good at it. Up until now I have been impulsive about getting tattoos, but I never regret any of them because I realize it meant something to me at the time. I am planning my next one and it will be a Hindu goddess stepping on a demon's head. Each of her six hands is holding something different, representing transformation. I continue to live by the words on my left arm. *"No matter how hard I hit the ground, I'll still smile,"* from the song "Smile" by Eyedea & Abilities.

Stopping drug use is not easy. Unfortunately, maintaining that sobriety is even more difficult. Providers of drug and alcohol treatment concede that relapse is part of recovery. It is expected that those in recovery will falter. Few get it right on the first try. But the endless cycle of abuse, sobriety, and then relapse is not the fate for everyone recovering from drugs and alcohol.

One's ability to maintain sobriety depends on many intervening factors. The first factor is having coping mechanisms and tools to resist the inevitable cravings. The second factor is creating an environment that is conducive to sobriety. That means identifying the people, places, and things that trigger the desire for the drug or alcohol. Obviously, the more available the drug is to obtain, the higher the risk of relapse. Consciously avoiding easy access to the desired drug will provide a safer environment to maintain sobriety. Third, the ability to regulate negative emotions is a major factor. The inability to regulate negative feelings (such as loneliness, anger, anxiety, depression, guilt) that created the need to self-medicate in the first place, will often invite relapse. Lastly, "support and attitude" can prevent a slip from becoming a full-fledged relapse. Those who can view a lapse in judgment as a slip are able to learn from it and become stronger; when they have support and take the slip seriously, they are more likely to establish long-term sobriety.

She demonstrates her use of these principles and her vow to achieve sobriety by declaring her next tattoo to be a goddess stepping on the head of her demon, while holding up all her recovery tools that give her the strength to transform herself.

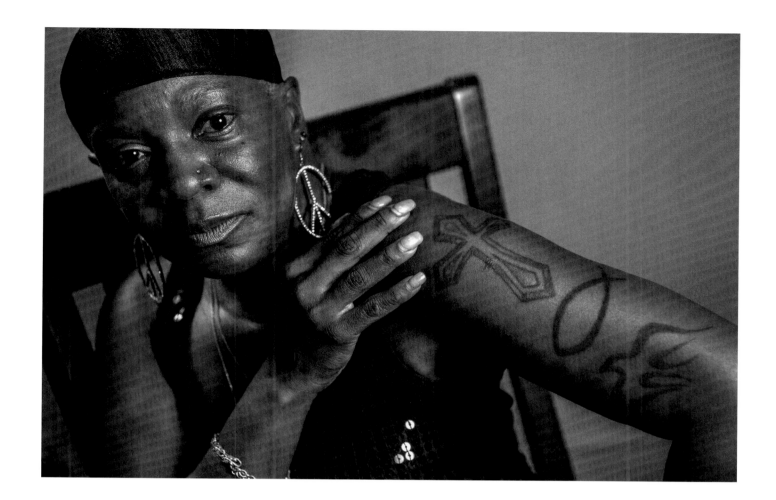

Dejection

DD Inge, Age 47, School Walking Guard

"I am not bound for any public place, but for ground of my own where I have planted vines and orchard trees, and in the heat of the day climbed up into the healing shadow of the woods."

—WENDELL BERRY

I have found peace and I am happy with me. It was not always that way. My mother made it very clear that she had me for my father, and when he was gone, she had no use for me. My sense of loss and emptiness was excruciating. My escape began around age seven when my uncle returned from the war. I noticed his tattoos. Since I could not wear pants, I could not have marks apparent to my mother. I began secretly doodling on myself with a pen, being careful of where I placed them. The rejection I experienced from my mother was compounded by the feeling that I never did

anything right and I was never good enough. Her controlling behaviors—telling me what to wear, who to speak with, and when and where to sit—stripped me of all freedom, that even a seven-year-old might experience.

The drawings on my skin, that included stick figures, footprints, and cars, gave me a sense of control and a secret from my mother. At night she always placed a glass of water at my bedside. Instead of drinking it, I sat up erasing the ink. I also drew stars, waves, and vines. I know now that the vines were the beginning of my authentic vine that starts at my

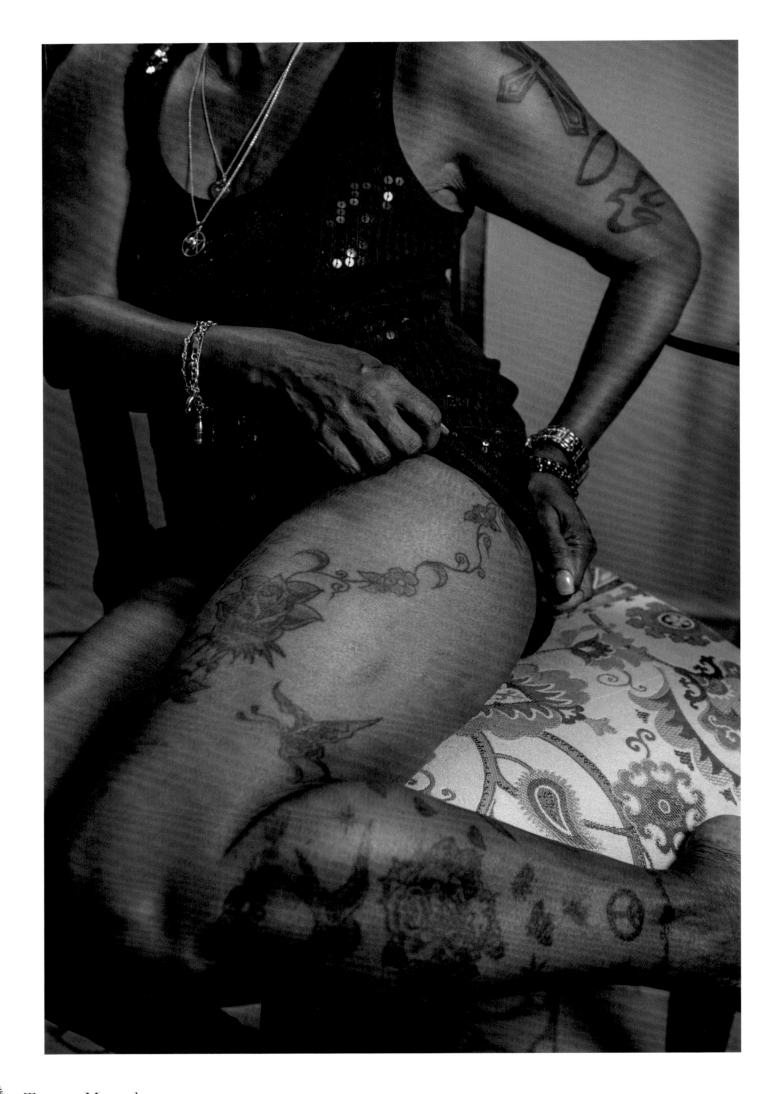

Tattoo Monologues

foot continuing almost without interruption to my heart and representing my life's journey. At age thirteen I got my first tattoo, and since that time they have followed a progression of health and illness, sadness and grief. The vine's flower on my foot was both painful and dark, signifying the hardships I endured as a rejected child.

A vine grows, and I always knew that a better day was ahead, that I would grow and that all things good or bad would come to an end. Objects hang from my vine much as they do from a charm bracelet. One of my many charms, the butterfly, was once a cocoon. As it transformed itself, so did I blossom into a woman leaving pain and negativity behind. This brought movement toward a more positive life. The flight of my birds and ladybugs talked to me about freedom, something so absent in my young life. When I get out of the shower and just look again at what I have created, I see my personal history. This vine is forever with me. It soothes me much like a pacifier soothes a child. A gap in the vine on my thigh will be closed only when my personal growth is near complete and I am living the life I wish to live. I am getting close.

DD's stories detail the healing that trauma victims experience when they are able to give words, symbols, or images to explain their trauma. Via tattoos, DD tells her story of recovery and accomplishes what other survivors gain from professional clinical help. Trauma is more than a physical experience. It is a complex abstraction of emotions, images, unwanted intrusive thoughts, and gut-level sensations that are difficult to quantify or concretize. When this abstract emotional memory, which is stored in the part of the brain called the amygdala, connects to the more analytical, linear part of the brain, the emotions and the meanings gain clarity.

By drawing or illustrating trauma on her skin, DD is able to give symbols and words to these floating feelings and begins the process of rewiring her brain. DD, with no professional training or knowledge of neurobiology, instinctively pursues the road to repair and a lifetime of healing. She is a testament to the wisdom of the soul.

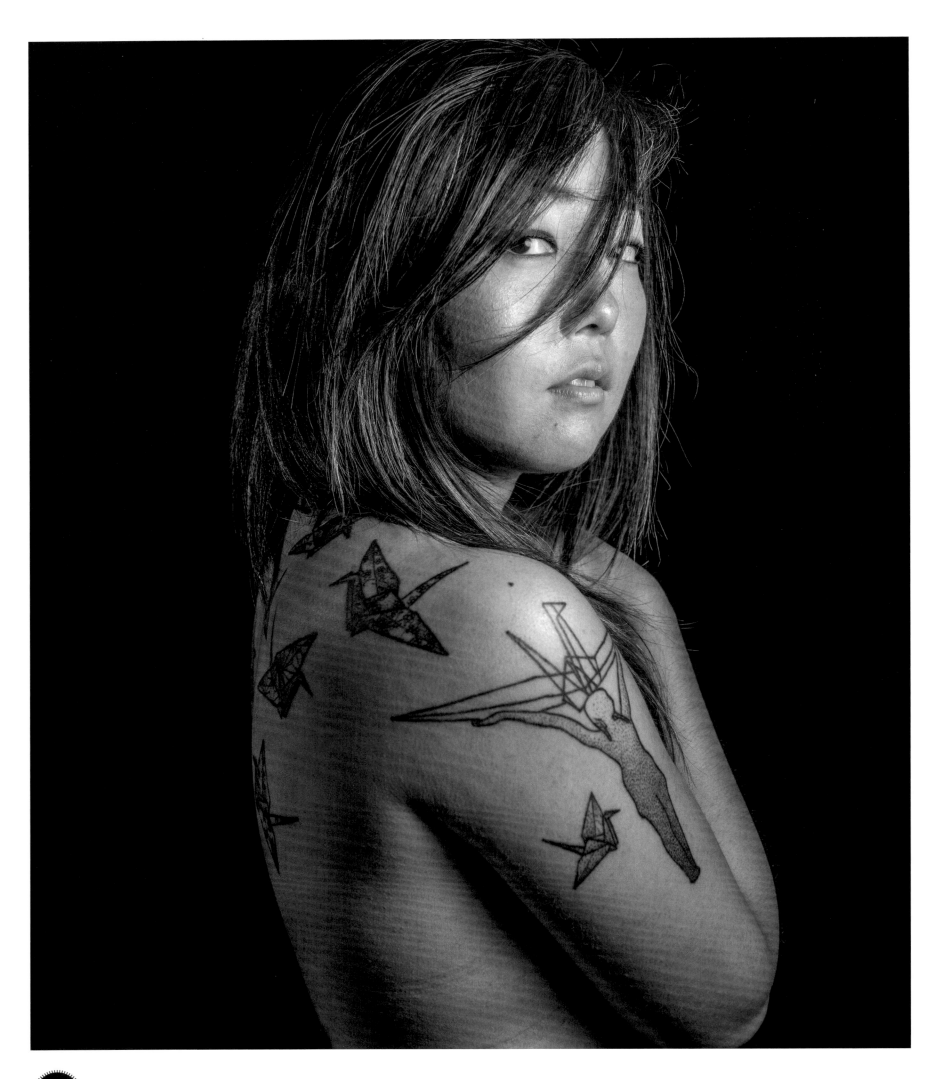

Tattoo Monologues

Paper Cranes

Aya Tasaki, Age 35, Attorney

"The conflict between the will to deny horrible events and the will to proclaim them aloud is the central dialectic of psychological trauma."

—JUDITH LEWIS HERMAN

My father's work took my small family from Japan to the United States, and so I was raised in both countries and had to learn to navigate dual cultures. The Japanese are known for the acceptance of their destiny. Acceptance of circumstance may partly be influenced by Buddhism. You might call it a fatalistic culture, managing what is out of their control, such as natural disasters like earthquakes, and even surviving an atomic bomb. However, the Japanese people are also averse to confronting negativity, which leads to avoiding, and even denying, the effects of human trauma. As a result, words go unspoken and emotions that need attention and healing remain hidden. Exploration of feelings has little value, inhibiting people from feeling connected, open, and vulnerable. Understanding this part of the Japanese culture has helped me put words to my own story.

Unlike Western culture, the Japanese do not see tattoos as artistic. Rather, tattoos are primarily associated with initiation rituals of the Yakuza, a corrupt underworld, which I liken to the Mafia. Tattoos are considered especially unacceptable for women. My tattoos are highly visible and cover most of my back, making a large statement. They are somewhat of a rebellious act and could be considered a "fuck you" to Japan; my relationship to Japan is highly complicated.

Both of my grandmothers lived within two kilometers of Hiroshima and survived the atomic explosion. A twelve-year-old girl, Sadako Sasaki, who later died of leukemia, is a symbol for those who survived the disaster. As she lay in a hospital bed, she utilized any paper she could, including her medication wrappers, to create paper cranes. The paper cranes became the emblem for peace and humanity, embracing the resolve that this can never happen again. The statue of Sadako holding a paper crane is located in Peace Memorial Park in Hiroshima. My Sadako tattoo is holding eight paper cranes, representing each member of my family, and connects me to those who I hold dear in Japan.

I was clearheaded when I first sat for the three and a half hours it took to create the design, and I remember the pain being so severe it brought to mind the suffering that my mother and grandmothers might have felt giving birth. The physical exhaustion I experienced afterwards was accompanied by the awareness that I had altered my body forever, and I was glowing in the aftermath of that exhaustion. I made a

very clear decision about my own body and I was not keeping it hidden.

There is a painful and complex part of my connection to Japan. Young Japanese girls are highly sexualized, and age thirteen is the age of sexual consent. Advertisements on television and on trains sexualize very young girls; this is considered pedophilia in other countries. I was a victim of multiple sexual assaults as a young teen barely out of grade school. This trauma made it difficult for me to come to terms with connections to others and to allow myself to be vulnerable. Instead, I turned my painful feelings into anger. My choice to stay in the US after my teen years might be a "running away" from that trauma. I am still on a journey to know how to relate to that young girl inside me and avoid holding her responsible for what happened.

My tattoo is helping me reclaim my body from Japan and to change the narrative. I could have done that by purchasing artwork that would punctuate and honor my journey, but I chose something much more visible and indelible. Because I had a loving and supportive family, my narrative was, "I had no reason to put myself in that situation so it must have been my fault." When I look back at photos of myself at that age, I am struck by how young I was. Still, I am unable to reconcile the fact that I had no fault in any of this. The perpetrator must have been about fifty years old. I realize now that I was not alone and many of my peers slept with older men to make money. *Kawaii* is the word for cuteness in Japan, and it is frequently used to describe young girls who are appealing to older men. I think I am still really trying to find the language to bridge the gap between who I am today and the person I left behind in Japan.

I am trying to hold on to gentleness with myself regarding choices that I make as an adult. I realize that being hypersexualized is often an effect of being a victim of sexual violence at such a young age. This tattoo is a commitment to both my current and younger self.

This is my first summer with the tattoo, and since I am an avid biker and more scantily clothed in the warmer weather, I am exposing my body art, and for those who care to inquire, my story. It gives me a feeling of power and pride. It is my statement to the world that I am a queer Japanese woman. I am getting a glimpse of the way it feels to be able to protect myself, and the ability to see the bigger journey I am on. I am taking back the narrative that says, "My instincts were terrible," and instead embracing confidence that I found a home inside me. I am self-reliant and every day provides a new meaning. I have never felt this before.

Aya's immigration process involved separation from her country, family members, and familiar customs. The stress involved in this process can cause or exacerbate mental health difficulties, including trauma responses and self-identity. Aya needed to assimilate from a collective culture to an individualistic culture, which makes the experience even more challenging. Collectivistic cultures, like Japan, emphasize the community's needs and goals over those of the individual. In such cultures, harmony and cohesion are valued over confrontation and assertiveness. This is the antithesis of individualistic cultures, like the US, that value self-determination, independence, and the rights of each person.

All of this had a major impact on Aya's development and self-identity. The emotions connected to Aya's childhood memories are conflicted and complex. Aya's tattoos were a way to resolve her traumatic memories. The emotions connected to her trauma created a harsh and judgmental inner critic. This is particularly meaningful when the trauma occurs during the developmental period of identity formation.

Aya's tattoo design was an image of Sadako, an adolescent Japanese girl who survived Hiroshima, a personal and national trauma. Sadako innocently created images of power, hope, and beauty out of scraps of paper. Posthumously, Sadako quietly empowered the nation to affirm that this trauma would never happen again.

The brain has the capacity to change when a felt memory evokes a new experience that changes the meaning of the traumatic experience. Interestingly, Aya associates the pain she felt while getting her tattoo to her mother's and grandmother's birthing experience. For Aya, this was her birth, the beginning of a new identity: an identity not of shame and self-repudiation but of empowerment, positive self-regard, and self-reliance; a self who is no longer controlled by the dominant culture. By emotionally connecting this new meaning to her trauma, Aya was able to integrate two irreconcilable cultures and reassure her younger self that she is protected and safe.

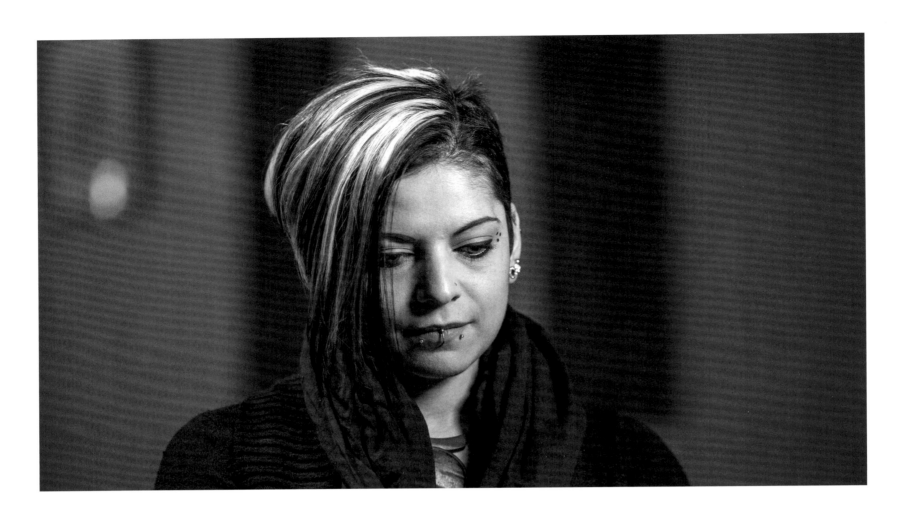

Lego Man

Jamie Arafin, Age 35, Third Grade Teacher

"She felt so much emotionally, she would say, that a physical outlet—physical pain—was the only way to make her internal pain go away. It was the only way she could control it."

—RACHEL MEAD

You might wonder why someone only in their thirties would have a terrible fear of forgetting later in life. It is this anxiety that led me to tell my life story in the form of tattoos so that they represent lasting memories of significant life events. It is very unusual to survive a ruptured brain aneurysm, but that is what happened to me. Everyone told me I should be grateful, so I buried my depression and tried to experience gratitude. As a result, I began to feel invisible both at home and at work, and due to that my life

began to fall apart. I left my job and my husband of twelve years. In memory of my husband, and in honor of *The Little Prince*, a book I read every year, I got a tattoo of the Little Prince leaving his planet.

I was twenty-eight when I had a sudden feeling of a fire in my head and my speech slurred. My life was saved by a seven-hour operation, but I was left with some frontal lobe damage that would take many years to resolve. I still have difficulty with word recall. I spent about a month in the intensive

Lego Man—Jamie Arafin

care unit, and afterwards I found I could not enjoy things that used to bring me pleasure, like watching movies or listening to music. In addition, I was very irritable and fired all the rehabilitation therapists who came to my home. For some reason that I still do not understand, I asked for Lego kits, a toy I played with as a child. Something inside me must have known that my brain needed something to keep it functioning. One day I walked into my dining room and found the table covered with Lego figures I had created, with no recollection of having done it. I looked terrible with a shaved head and I was getting married in several months, so I thought I would grow a mohawk for my wedding, but my boyfriend objected. If I could not have a mohawk, at least I could give Lego man a mohawk and tattoo him on my back. I included my scars and piercings all imbedded in a large star. The pain of the tattoo by my spine was intense, but afterwards it was like the pain after a good workout. I felt like I got something out of it; it was worth it.

My tattoos are not only my storybook that keeps my memories alive, they also can serve as an emotional release, like the time I was so angry after having a fight with my boyfriend's brother. The fight was emotionally painful and I did not want to cause anyone pain. I got a large tattoo on my back, which caused me physical pain but also helped me release my anger. I recently got a cartoon character, She-Ra, on my shin for my brother, and now I need to get one on my other shin. I have sat for ten tattoo sessions; the only thing that holds me back from more is money. Tattoos can be addictive for me; perhaps I need a sense of balance.

The physical pain that results from getting a tattoo can be cathartic. Analogous to cutting or self-harm, tattoos can serve as a coping mechanism, albeit sometimes seen as negative. They can be ritualistic and lead to lifelong repetitive behavior, or "addictive" as Jamie describes it. It can be difficult for others to understand the reasons why someone would choose to self-inflict pain. Sometimes a tattoo serves to express overwhelming feelings that are too distressing to put into words; to feel the sense of release from tension and emotional pain; to self-soothe or decrease anxiety, sadness, and guilt; or to feel alive.

Reclaimed

—◆—

Jeanette Harrington, Age 41, Personal Trainer

"The unconscious mind always operates in the present tense, and when a memory is buried in the unconscious, the unconscious preserves it as an ongoing act of abuse in the presence of the unconscious mind. The cost of repressing a memory is that the mind does not know the abuse ended."

—RENEE FREDRICKSON

At ten I was terrified to go into a basement without any understanding of the reason. As I got older and was in college, I moved into a basement apartment. It was then that it all came back to me, and I found that I could not go there without feeling a sense of terror. It was as if I was surrounded by something trying to hurt me. I had to envelop myself for protection. I began to remember what had occurred: our next-door neighbor molested me in the basement of my own home when I was between the ages of three and four.

On my back is a wolf encased in a sun. It is a Pacific Northwestern American Wolf. The perpetrator's name was Wolf. Some people might think it is crazy, but I wanted to take the name, and the power, back, and this power and energy live inside the sun. I can tap into the painful experience and feel an enhanced sense of power, which brings me a more fulfilled and peaceful life. I feel strongly that it has helped me recover. I chose my back because it is connected to my energy source, the Dan Tien.

I have not thought about being sexually abused for a long time, but I am feeling very emotional about it at this moment. I used to think about it and live it every day, but now I don't think about it.

When I was a child, my family moved from that house in Minnesota, but sometimes we would go back to visit. One time I saw the perpetrator standing outside of his house. I wanted to jump out of the car and scream and yell and hit him, but I did not have the guts to make a scene. I think it was crazy; why was I the one to feel ashamed? It was very difficult for my parents when I finally told them. They did not rant and come out with guns blazing as I had hoped. Instead, they internalized the feeling and did the best they could. Even so, I know they love me and want the best for me.

I have a lot of support from my siblings and from my very sweet husband. We have two daughters, ages seven and nine. For a long time I was so frightened someone would do something to them, so I was afraid to leave them. I remember dropping my oldest off at nursery school for the first time,

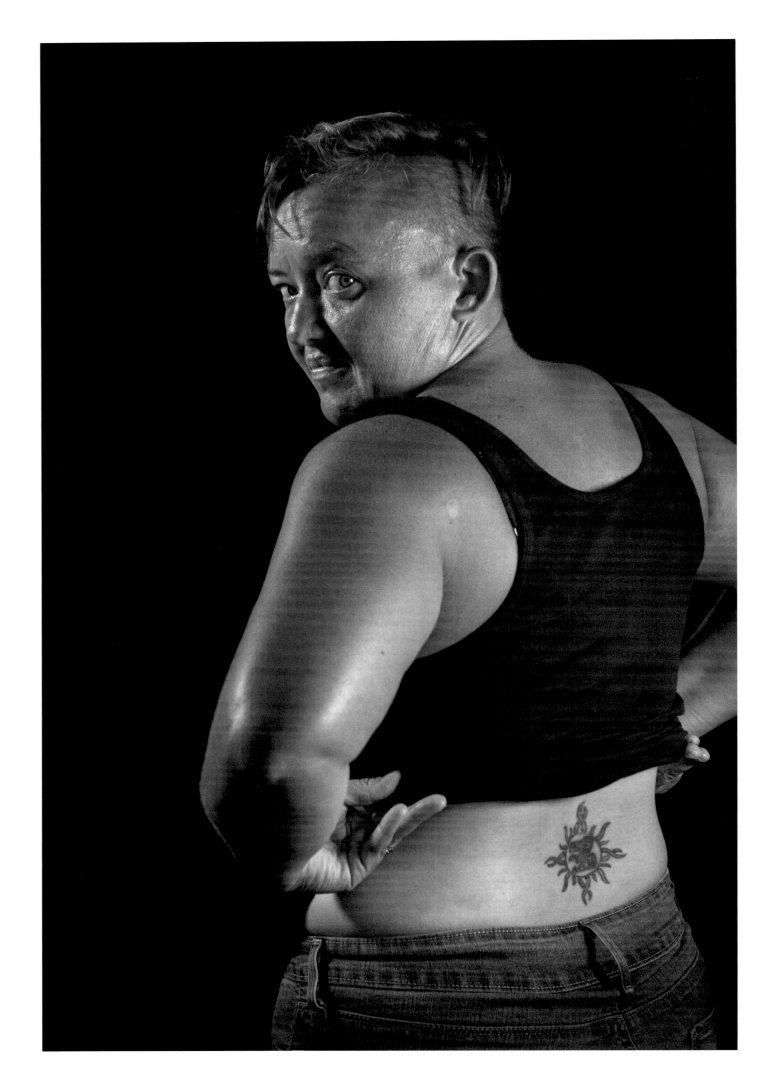

feeling terrified. I would check her body and watch for unusual behaviors. I am not as freaked out now because they have a voice and they know it is appropriate for them to say "No." I am aware of how they will be treated by our society as women. They will be devalued, cat-called, and maybe touched inappropriately, and they have to be prepared for that. For now, my husband and I make thoughtful decisions about where we take them and avoid adult parties where there is a lot of alcohol.

I have two other tattoos that form a triangle, and they are a huge positive power source for me. I have a raven on one foot representing my older daughter's power animal. The symbol on my other foot, for my younger daughter, has a more complex story to it. It is the beautiful picture above the mausoleum of a fourth century woman in Italy. She was a bad ass who killed her husband and the other village men in charge in order to run business her own way.

Jeanette's story is about a woman who repressed the memories of losing her childhood innocence and purity before she could even appreciate what those qualities were. Unlike many survivors of early trauma, Jeanette protected herself from experiences that were too frightening for her young brain and body to understand. She pushed those memories way down to a place so dark she hoped they would never see the light again. This worked for Jeanette until she was faced with the ordinary event of moving into a basement apartment, which triggered a glare of frightening, unwanted memories.

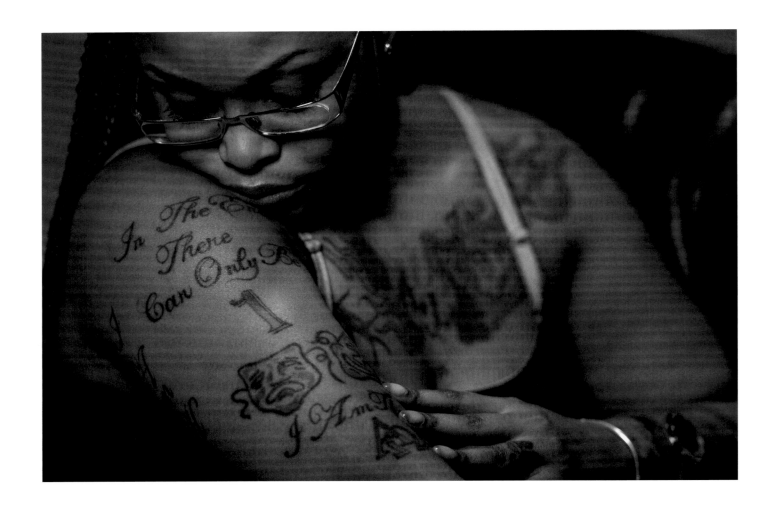

The Gift

Kimberly Matthews Jones, Age 32, Behavioral Health Coordinator

"It is really painful to let go of someone you don't want to go. But it is more painful to ask her to stay when you know that all she really wants is to walk away."

—Author unknown

Until I was twelve, I swore my sister hated me. I had been told that she threw me under the bed when I was an infant because she was jealous. When I was twelve, something shifted. My sister, Ch'nia, four foot eleven inches tall and ninety pounds, defended me against some big guy who was harassing me. From that time on we became very close; she was my big sister and I knew she loved me. As she got older, I wonder if she had a premonition that her life would be short. After losing two pregnancies at seven

months gestation, determined to try again, she gave birth to a healthy baby boy. She had been warned that some women were not meant to carry a child, but she insisted that she needed to give our mother a grandson. We would find out some day how much we needed that little boy; he was a gift.

Ch'nia was strong-willed, stubborn, and could be defiant. Although she knew she had an allergy to seafood, she ignored this fact and believed that taking a Benadryl would protect her. As I arrived at our home on a sun-drenched

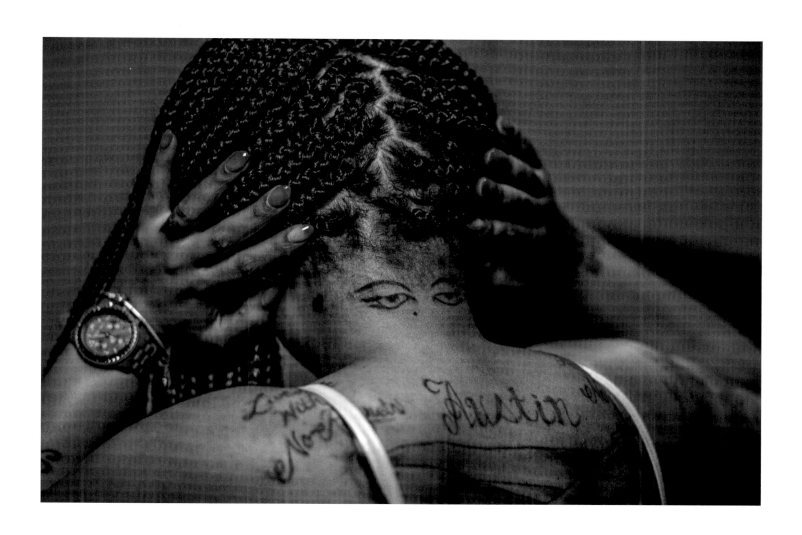

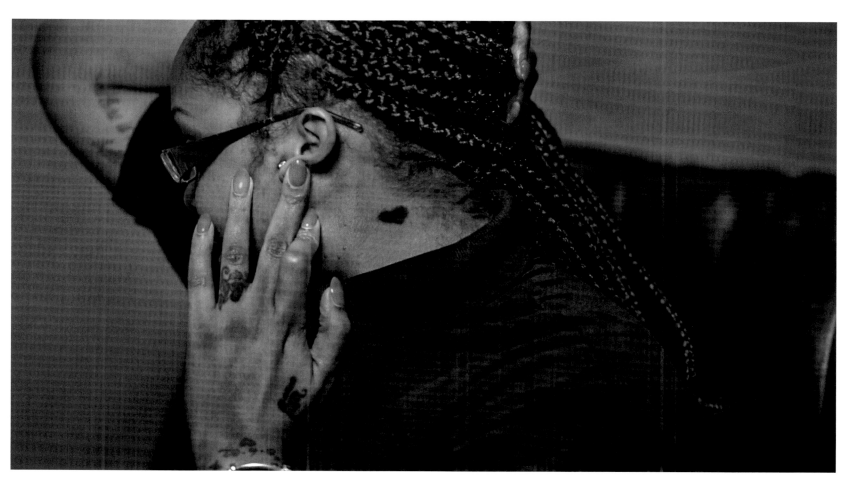

summer afternoon for the cookout she and I had planned, I was alarmed to see an ambulance at the curb and the terrified look on the faces of my family. I was told by a cousin that Ch'nia's heart stopped. I knew immediately what had happened and that she was gone. She was twenty-two years old, her son two and a half. In remembrance of her I asked my tattoo artist to imprint a teardrop on my face. He refused, caring more about me at that moment than making a dollar.

For the next six years, I was furious at Ch'nia for doing this to herself, and to us. It was as if she had overdosed. The pain in me made me emotionally numb and absent from myself. I had not allowed myself to grieve. The sadness in my mother's eyes was excruciating. Experiencing a deep depression myself, I took a pill daily that enabled me to sleep away much of my life. I dreamt of my sister every night, and in each scenario she was walking away from me. When I finally confronted her about her meanness, she told me I needed to let her go. That woke me up to the realization that I needed help, and I soon learned from an insightful therapist that I had been resisting grieving for a long time.

Recovery has been a long journey. Though I will never go home after a difficult day and find my sister there to comfort me, I just feel like she is there. My tattoos keep her alive in my heart. "Gone but not forgotten—DOB 9/11/79 Died 8/6/02" covers my right arm. She had a tattoo of a red heart with wings on her right foot. I duplicated it also on my foot in her honor.

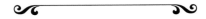

Kimberly conflated Elizabeth Kubler-Ross's stages of anger, denial, and depression, leaving her overwhelmed and emotionally numb. That was all part of Kimberly's grieving process. Grieving without process can be devastating. With the support of a therapist, she was able to untangle, understand, and manage her flood of emotions.

When people lose someone they love, the bereaved are often encouraged to put the loss behind them. Freud claimed that the bereaved need to "let go" in order to move on. However, when Freud's favorite grandchild died, he asserted that he would never get over the loss.

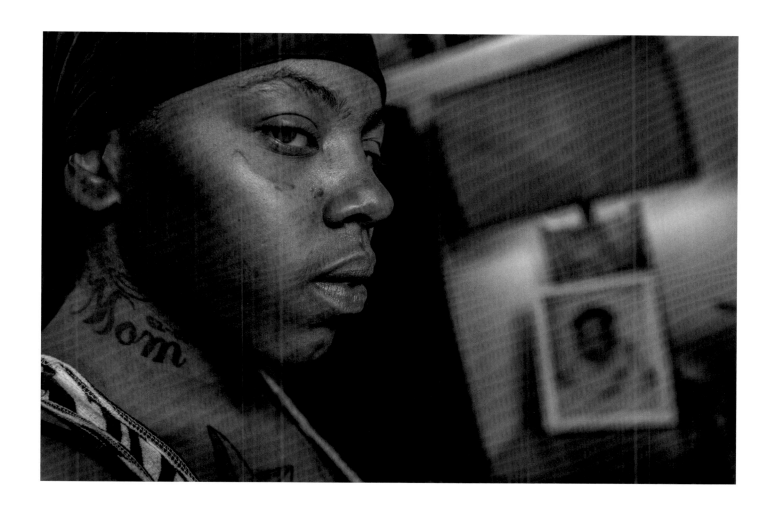

Guardian Angel

Jocelyn Simmons, Age 28, Homemaker

"Despite the rising popularity and prevalence of body art, many still consider the phenomenon to be one of socially sanctioned self-mutilation; a permanent stain of youthful rebellion, practiced without due care and attention to the long-term consequences."

—HELEN MIRREN

It was just a few days after she died that I got my mother—my best friend—tattooed on my neck. It simply says "Mom" and the date she was born and the date she died. She was far too young to leave us, only in her forties. Sometimes I rub her tattoo and I feel like she is by my side watching over me, just my own guardian angel.

My mom was sick for about seven years; the last two weeks were the worst. When I asked her what she wanted at the end, she said, "Don't let me suffer," so I let her go peacefully, steering clear of excessive interventions. Because she was my best friend, a day doesn't go by when I don't think of her. When I was down, she always made me feel better. I was her only daughter, and her caretaker, and I never left her side. Sometimes it was hard, and I had to be her mother, like when she did not do what she was supposed to, like keep her oxygen on, take her medications, and stay off cigarettes.

Because of this, I missed some of my childhood, but I don't regret any of it. I have a lot of happy memories with her. She was kind, often silly and outgoing, family-oriented, and had a loving heart. She would give you the shirt off her back. Sometimes we had lots of family members staying with us because she could never say "No" to anybody.

Some people go shopping when they are stressed or depressed, but not me; I get a tattoo. It takes me into another world, and it takes me away from what I am stressed about. I get happier and I socialize more. Even though I have twenty-two of them, I keep them where you can't see them; not on my hands or face, because if they show I might not be able to get a good job. When one of my three daughters asks me about getting a tattoo, I tell her she needs to wait until she is at least seventeen; you don't want to get one that you will regret because it is with you for the rest of your life. The only ones I regret are the ones that do not have a lot of meaning.

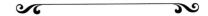

A tattoo can make something personal very public and vulnerable to judgment. Our culture has preconceptions about people who have tattoos, the type and meaning of the tattoo, what number of tattoos are deemed appropriate, and where the tattoo is placed. Emerging from their often-unsavory reputation of the recent past, tattoos have gained increasing prominence in the past decade and have lost some of their previous stigma. In 1936 LIFE magazine reported that approximately 6 percent of American adults had at least one tattoo. In 2012 the Harris Poll estimated that 21 percent of Americans had one or more tattoos. Still, potential employers, landlords, and new relationships may be affected by negative cultural stereotypes. Jocelyn loves her tattoos but understands that there are still employers who might consider it unprofessional. Body art can be challenging and misunderstood.

Gemini

———— ◆ ————

Kenzie Viser, Age 23, Credentialing Specialist Health Care

"My body is my journal and my tattoos are my stories."
—Johnny Depp

Following the destruction of my home by a tornado, I left Reno, Nevada to come to Philadelphia for a job as a Credentialing Coordinator. I like to consider my tattoos a visible testimony to people and events that have changed my life. For example, on my forearm I have a ship that says, "Once I was lost." I think everyone goes through a series of trials and tribulations trying to find themselves, a season to find stability, and that tattoo symbolizes the experience. My best friend Megan passed away in 2013 from bone marrow cancer, and I have this diamond tattoo in memory of her because she was a diamond. She could just walk in a room and shine—not just the typical shine, she would illuminate a room; I love and appreciate her for the experiences she gave me.

My most recent tattoo is that of an eagle because eagles fly alone, symbolizing my flight to Philadelphia. I am undergoing a transition, a new becoming. On my chest, "No weapons shall prosper" means nothing will deter me from my dreams, my goals, and my foundation.

The words "Respect and Honor" line the inside of my wrist because without mutual respect, and respect of the environment, you have nothing to stand for; you are nothing. I am friendly and outgoing, but I also have anger and

frustration. I have a panther on my left thigh symbolizing my aggression. On my right thigh, I have snakes and daggers, which remind me to be watchful that there may be snakes around with bad intentions.

My values come from a very strict mother, a virtuous woman who showed me the right way. When I come upon someone whose values are not mine, I just try to stay away from them and remain who I am. I have my mom's name on one foot and my grandmother's on the other. They walk with me and I have them to thank for who I am today.

I like to keep a good attitude and know that it all will be okay. But that is not all of who I am; I am short-tempered and can be aggressive. Though my mother is in my life and led a good example, we did not always have the best relationship. She was held captive by drugs. I carry much resentment toward her to this day, and I am working on that. The state was giving my mother money, and instead of helping to support her children, it supported her drug habit.

Even so, I embrace all sides of myself, even the anger. Sometimes someone may say something irritating to me and it just sets me off like a switch is pulled. I remind myself that even strong emotions are temporary, and when I feel a strong

emotion, sometimes I just need to slow myself down. The last tattoos I want to tell you about are my angels representing love. The angel wings on my back are the angels who protect and make sure I am okay wherever I am.

On my left arm I have a pin-up girl encircled by dice and cards that states," Love is a gamble." When you take a chance on love, you never know what is going to happen or how your cards will play out. Even if you go in with a good hand, anything can change. I needed a tattoo to make me mindful of giving and receiving love because I would not want to mess up my hand of cards.

The two sides of my personality are represented by the two koi fish on my right arm. I am a Gemini. I know some people do not believe in horoscopes, but my personality is reflected in the Gemini twins. Sometimes I think I am a little crazy. The sign of the twins is hot and cold. It is always Jekyll and Hyde when it comes to me, and I am trying to find peace and serenity in the midst of my confusion.

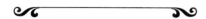

Some people may say their life is an open book. This is true for Kenzie, and every tattoo is a chapter. Kenzie's body is a historical archive of powerful events, declarations, and transitions in her life. She has come to embrace each chapter as the sum total of her personhood. Each tattoo, however painful or joyous, tells Kenzie's story, and she wears them proudly.

Recovering

Kerry Arnold, Age 45, College Faculty/ Behavioral Health

"Stories have to be told or they die, and when they die,
we can't remember who we are or why we're here."
—SUE MONK KIDD

For me, the time had come that what I felt on the inside would be manifested on the outside. The tree of life with the Alcoholics Anonymous (AA) triangle (service, unity, recovery) drawn on my right thigh celebrates my twenty-six years of sobriety. I drank my way through a decade in my twenties before I heard a voice one night say, "You know, that is going to kill you." When someone held out a hand, I took it and I attended my first AA meeting. I never drank again.

My life was plagued by secrets. I did not find out until I was six that I was adopted, and it wasn't until I was older that I came out as a lesbian. I told myself a story that "I was not loved or lovable and I felt like a victim." The victimization that emanated from pain led to my drinking, and when I finally put that notion to sleep, I also gave up alcohol. Part of the healing for me began when the inside of me began to match the outside of me. My tattoos represent healing and redemption.

For fourteen years I shared my life with another woman, and I became very close to her parents. Her father flew planes, and when he was dying of pancreatic cancer, I asked him how I was going to know he was around. "You know girl, I'll be flying," he said. Sitting out on our deck one day, I noticed a monarch butterfly that kept hovering. It actually landed on me and allowed me to stroke its wings. I was certain this was

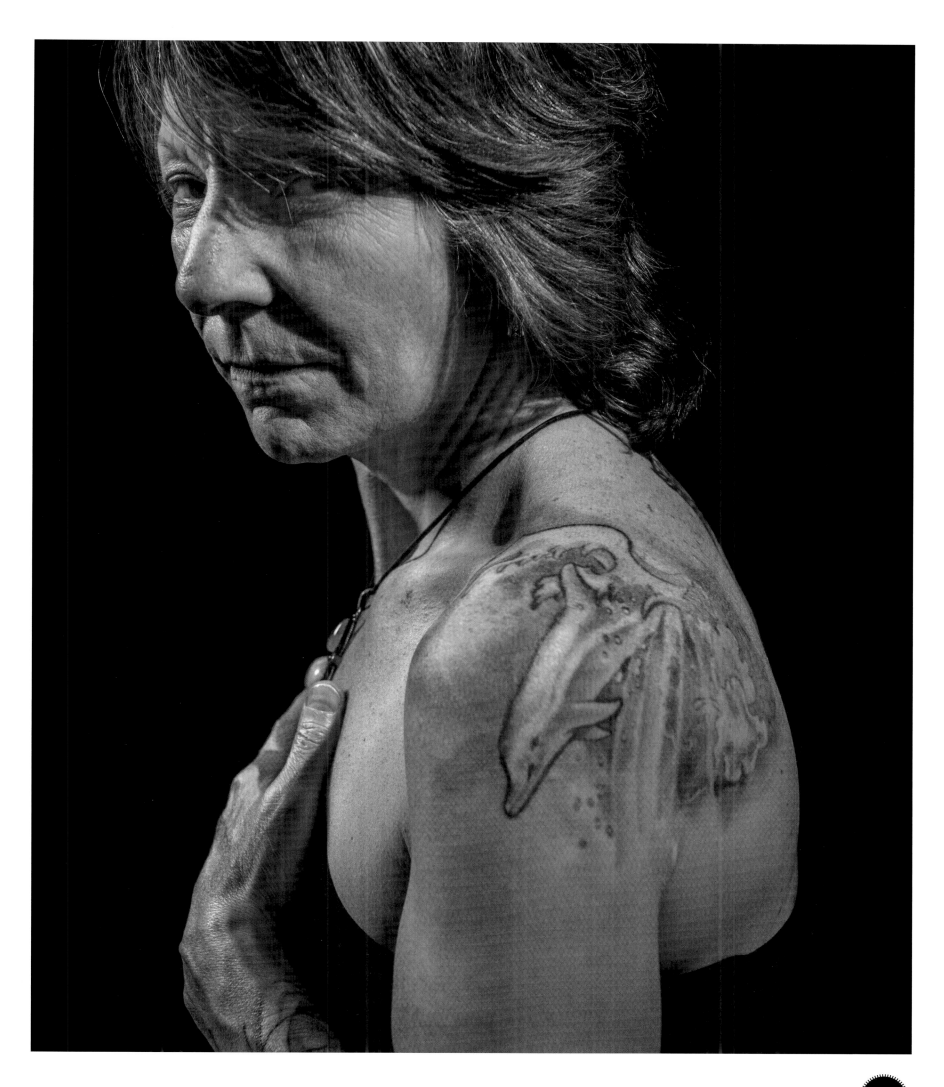

Phil paying me a visit. I had a strong relationship to the other side, and going through the dying process with him took me to a deeper spiritual place where I became immersed. The butterfly drawn behind my neck assures me that Phil will always have my back.

My father was an alcoholic (another family secret) and drinking finally claimed his life. One of my happy times with him was going fishing, and I remember him protecting me from catfish whiskers that I feared. My koi fish tattoo with the whiskers commemorates my dad.

The process of getting a tattoo is a very intimate one, and in the process I am opening up. I am allowing her (the tattoo artist) to inflict physical pain on me; she wipes away the blood, and it becomes a ritual, one that I drive two hours to experience. For me, I must deeply trust the artist, and she becomes a spiritual partner. Throughout the process of getting tattooed, the dirty little secrets in my life shift to a period of personal growth. I give rise to my grief, which gives rise to the portrayals on my skin.

I used to be very butch, but as I have become more spiritual, I have become a softer person. I have allowed my femininity to come through, and this shift is marked by the goddess of compassion on my low back. Similarly, dolphins are deeply spiritual and magical for me. Where I have this lone dolphin emerging from a hibiscus flower, I am acknowledging the loss of a fourteen-year relationship and my lone journey.

Kerry's tattoos are autobiographical. She tells the stories of people and experiences that have shaped her life. She tells these stories not only to say, "This is who I am," but these stories will always be imprinted on her body to remind her that "These stories made me who I am."

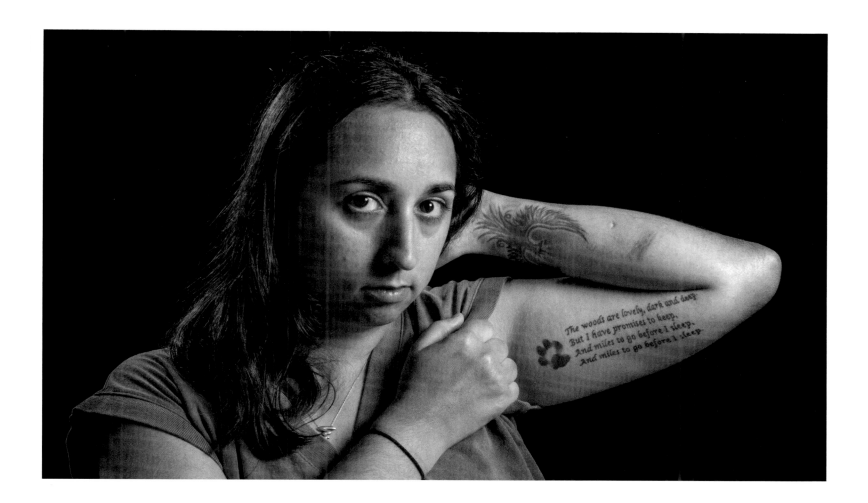

Rescued

— ◆ —

Lauren Silverstone, Age 28, Social Work Student

"I suppose that since most of our hurts come through relationships so will our healing, and I know
that grace rarely makes sense for those looking in from the outside."

—William P. Young

October 2013, I was twenty-five years old, and it was my first day of work in an animal shelter where I always wanted to work. It was the end of the day and I knew that the animals, more than fifty of them, still needed to eat before we closed. There were sibling pit bulls, and as I moved the bowl in their kennel, the male latched onto my arm and his sister joined him a few seconds later. Fortunately, there was a volunteer there who was a nurse, and she used a leash as a tourniquet to stop the bleeding. I was taken to a community hospital and then transferred to a

larger medical center in Philadelphia, where an amazing hand surgeon saved my left arm. After that, I had many surgeries and about a year of physical therapy. The therapists could not have been kinder to me. They made me laugh when I was so depressed. It was people like them, and my little Chihuahua dog Elf I had just rescued, who saved me.

Elf stayed in my bed by my side. He knew I was not well; he was awesome. My depression made it so that I could barely get out of bed; I was dependent on my parents for every-thing, and Elf depended on me. I had rescued him, now he

was rescuing me. If I didn't want him to wet my bed, I had to get up and take him out. During this time I had to think about how I was going to make a living; I knew I would not have enough confidence to return to the animal shelter. I was diagnosed with PTSD and saw a Licensed Clinical Social Worker. I always had an interest in psychology, and she helped me plan my career and decide on social work school, which is where I am now—my last semester at Widener University. I don't have nightmares and flashbacks anymore; the event is more like a memory.

My arm is about 90 percent better and I can play the piano and sports like football. That is great because I am a jock. I have a passion for the military and want to work with veterans; I will understand their PTSD and might be able to help them with service animals.

I have many tattoos, and some are about loss, like the number of the house I grew up in with a rosebush on each side. But they are also celebratory, like life is moving on. There is a poem by Robert Frost ("Stopping by Woods on a Snowy Evening") I had seen many times before that now resonates for me. The last part has become my mantra:

The woods are lovely, dark and deep,
But I have promises to keep,
And miles to go before I sleep,
And miles to go before I sleep.

This poem and Elf's paw will forever be imprinted on my left arm. I live and breathe for Elf; he is my baby, and he and other people need me to keep on going.

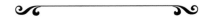

Not all victims of Post-Traumatic Stress Disorder (PTSD) have lasting symptoms. There are many resilient people who experience no symptoms, and for some the intrusive, painful reexperiencing of traumatic events fades into a sad memory. When the trauma is inflicted intentionally by a known loved one, the betrayal and injury is greater. Trauma can endure when the victim generalizes their fears, allowing the triggers to increase in frequency and intensity. For example, a person raped at a playground at dusk by an adolescent boy may get triggered by dusk, adolescent males, males in general, or playgrounds. To overcome such triggers the person benefits by having a "corrective experience." That corrective experience may be developing a friendship with an adolescent boy who is kind and respectful, or developing a trusting and safe relationship with a male therapist.

Lauren's dog, Elf, was dependent and vulnerable, and thus the antithesis of the overpowering and overwhelming experience of her violent attackers. A therapist may view Elf as instrumental in providing Lauren with the corrective experience needed to deflect those triggers. For Lauren, Elf is a Chihuahua with wings.

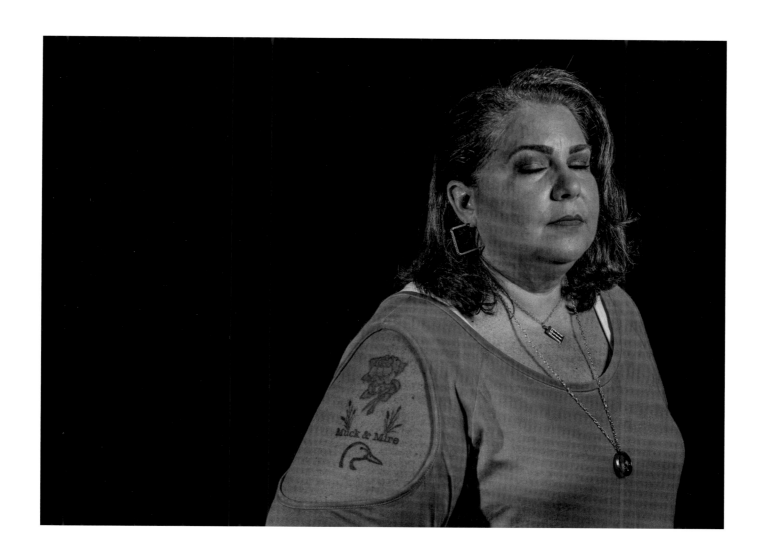

Muck and Mire

Lisa Infante, Age 48, Corporate Travel and Event Coordinator

"Death ends a life, not a relationship."
—Robert Benchley

"Muck and Mire" imprinted on my right shoulder provides me with the opportunity to talk to strangers about the man I adored as a child and still do today. This was the name of the boat he would drag into the marsh time and again. Duck hunting was a huge part of my father's life. He was an active member and leader in the organization Ducks Unlimited. As a young child, my sister and I spent many days working with him on fundraisers for the organization that protected the habitat of these creatures. The night he died of a heart attack was both the saddest and happiest of my life, as his death preceded the birth of my first grandchild by five hours. Imagine what it was like for me to tell my daughter about the death of her grandfather only hours after the birth of her first child. To say he left a giant hole in my heart when he left us is a massive understatement.

My father adored his family, and trips to campgrounds and fishing holes were a common occurrence. If one of us said we were in the mood for a sandwich from Harold's Deli, off we would go from Philadelphia to North Jersey or New York for the sandwich and the best cheesecake.

For some reason that I still do not understand today, when I was twelve, our parents took us to run in a six-mile race in Central Park. After crossing the finish line, I seemed to have gotten lost in the mire of people, and it was nearly an hour before I spotted my parents. I was stunned to witness tears coming from my father's eyes for the first and perhaps only time.

My father was my hero and filled the same role for my niece and my son, who also proudly wear ducks on their skin.

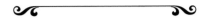

Lisa's tattoo is a memorial to her father's life. It captures and preserves the memory of her father's love, along with the emotional bond between them. The holding onto the love of a deceased loved one need not have negative psychological effects. Death ends life but it does not end the relationship that lives on in the mind and heart of the survivor.

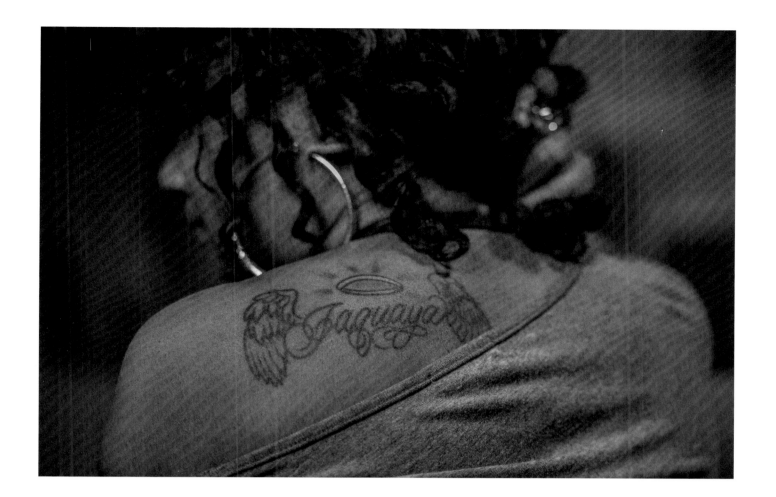

She's Got My Back

Manya Echols, Age 47, Office Manager Community Health Center

"In the English language there are orphans and widows,
but there is no word for the parent who loses a child."
—JODI PICOULT

It was a rainy night in October. Jaquaya was on her way to a masquerade party with a friend when the car hydroplaned, and they hit the median on the Pennsylvania Turnpike. They didn't know not to get out of the car, and that is when the accident happened; another vehicle on the turnpike plowed into them. I miss her so much; I would do anything to have her back.

I always wanted a tattoo, but I was afraid. When my daughter, Jaquaya, passed away at age twenty-two, I went to an artist. I didn't want the usual R.I.P. (Rest in Peace). The artist drew her name cradled in a haloed pair of angel wings, and I clung to that picture. She was my anchor, so it is fitting that I have her on my back because she always "had my back." I feel as if she is riding on my shoulders, and I feel her presence and her closeness.

Jaquaya had twin brothers who are autistic and have severe developmental problems. From the age of eight, she was a little mother, changing diapers and administering medication. She was so attuned to their special needs; it is no wonder she was studying nursing in college and planned to

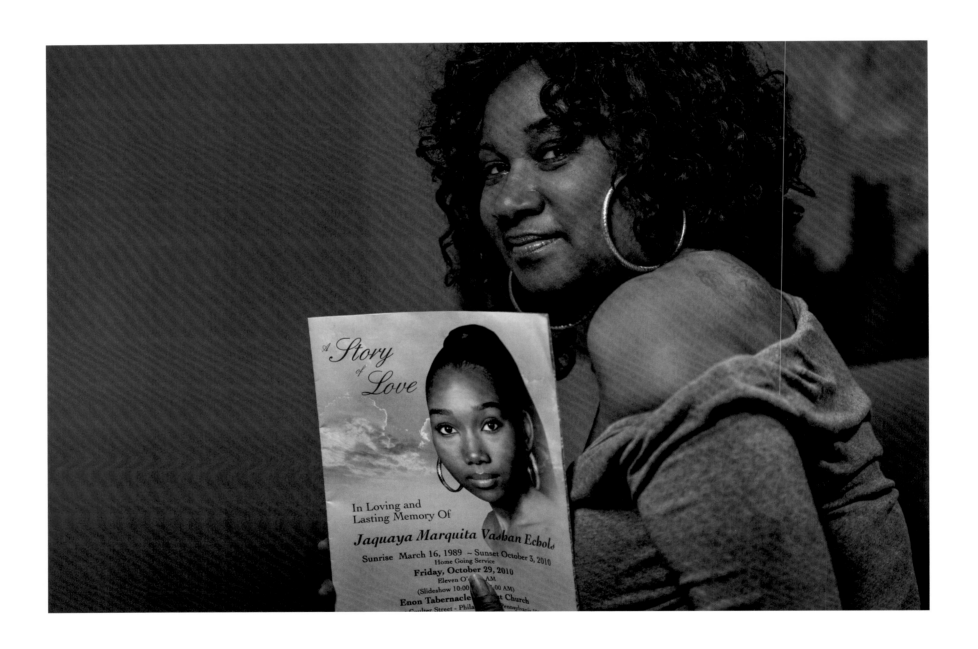

Tattoo Monologues

work with handicapped children. She handled her caregiver role like a trooper because that was our life. My life would be less burdensome now if she were here. She was my heart, my courage, and my strength. It may sound like she was more an adult than a child, but I always made sure she had a life befitting her age.

She is gone now, and I am overwhelmed with emotion and how much in love I was with my daughter. I feel an emptiness now that is difficult to explain and at times is unbearable. Sometimes I just sit in her room and sob. It seems as though I think about her constantly, though not all my tears are sad tears; there are fun tears, too. I think of the times she made me laugh. I know she is in a good place now, and that soothes my heart.

It will be five years for Jaquaya next October. The first year was hard, and her absence gnawed at me as I celebrated her birthday, Christmas, and Mother's Day. If it helps someone else, I would tell them it will be okay, life does go on; you have to adjust your life, you have to find a way to dig deep to muster up all the courage you can find. Now I have more good days than bad days, and I am comforted by the belief that she will continue to always have my back.

The death of one's child may be one of the most traumatic losses that can occur in adult life. Children, regardless of age, are not expected to die before their parents. Jaquaya's existence was part of Manya. Manya grieves for both the loss of her daughter and a loss of herself; she grieves the loss of hopes, dreams, and possibilities of what could have been.

When death comes suddenly, the emotional lack of preparation makes the grieving more complicated. There is no chance for the griever to have proper closure with their loved one, nor the opportunity to work through unresolved grief from earlier in their life. Manya's tattoo is the name of her daughter placed on her back. For Manya her tattoo is more than a gravestone; it permanently concretizes and maintains Manya's connection with her daughter Jaquaya.

The Slide

❖◆❖

Melissa Morton, Age 48, Behavioral Health Coordinator

"My mom is literally a part of me. You can't say that
about many people except relatives and organ donors."
—CARRIE LATET

I believe the pain of getting the tattoo mimicked the pain in my heart. In 1990, I was twenty and it was long before tattoos were so popular. Indicative of my youth, I remember I had a blow pop in my mouth to keep my mind occupied. "Celia and James, I miss you." Never thinking I would lose both my parents by age twenty-one, I took them for granted and thought they would always be with me. My mother had breast cancer. At some point she was so busy taking care of my father after his knee surgery that she ignored a lump that would go on to take her life. It all went very fast; she lost her hair, and then there was the double mastectomy. When the doctors told my father that the cancer was so advanced, he could not find the courage to share that news with me and instead asked the doctors to explain. I remember so vividly: I was leaning against a hospital wall and I slowly slid down before hitting the floor. Those words, "She is not going to make it," continued to ring in my ears and must have caused my legs to buckle.

My parents were soulmates, and after my mother was gone, my father just gave up, depressed so deeply that there were days he never emerged from his bed. Within two years he died of a broken heart. Shortly before his death he called me down to his den in the basement. "Melissa," he said, "I am not going to be here your whole life, make sure to always pay your bills, don't ever fall behind, do what I tell you to do, and you will be alright." I know now what I did not know then; he was beginning his goodbye to me and preparing me to live as an adult.

As an only child, I was now orphaned. I was angry; I was too young for this to be happening to me. Suffering sometimes gives us strength, and I would not be the woman I am today had I not had to grow up so quickly. I was left with a house to manage and bills to pay. I had to learn street smarts as my parents had protected me from all the negativity in life. I was more emotionally connected to my mother, and I realize now how much she did for me. I know this is going to sound strange, but my mother even helped me put on my stockings so they would not wrinkle at the bottom. We often went to eat and shopped together. She was a very sweet, church-going woman. I remember when I was in trouble, she never stayed mad at me very long. Next thing I knew, she would be hugging me. I have become that kind of parent. If she were with me today, I would tell her how grateful I am that she showed me how to be a good wife and mother.

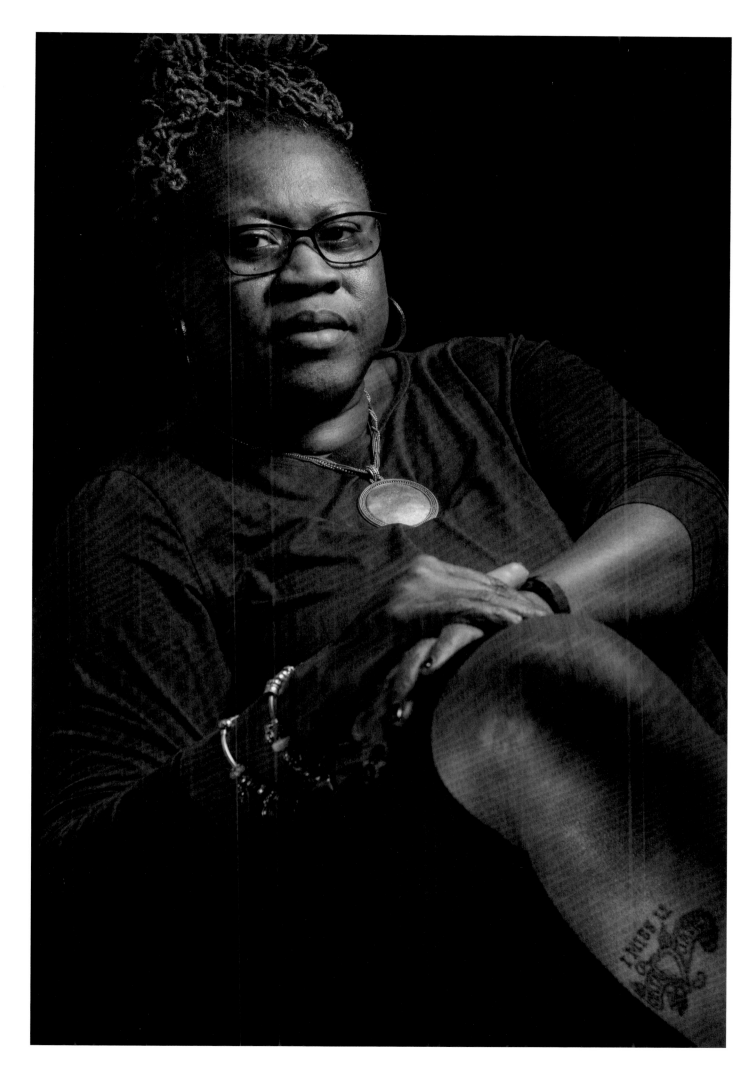

I worked in hospice care, and then in women's health prior to my current work coordinating a behavioral health department. I wonder if my choice of careers was influenced by the loss of my mother. Hospice was especially hard; I would connect to my patients by listening and caring for them, and sometimes they were gone by the next day. That triggered sadness and was more than I could handle.

I missed my parents at my wedding, when my child was born, and especially on Mother's Day and holidays. I know they are smiling at me and they would be proud of what I have made of my life. If my dad were here, he would still be schooling me. What I miss most about my mother is her hugs. My tattoo helps me keep them with me in my flesh and in my heart.

It is not uncommon for individuals to select careers to work out unresolved emotional issues. A child with health problems becomes a medical professional, the victim of rape becomes a trauma counselor, and the child who lost her parents to painful illnesses becomes a hospice worker. There is always a second chance to make it all right. What we cannot conquer during an earlier developmental stage can still be accomplished later.

Even with resolved grief, there will be significant times in Melissa's life when her parents' absence is melancholic: the birth of a child, a wedding, a graduation, certain developmental landmarks or achievements, etc. These are the times when Melissa's grief may be triggered.

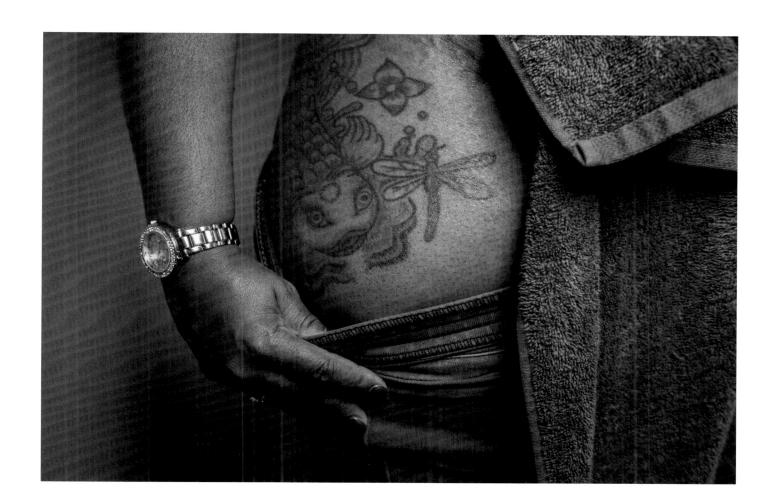

Hope in a Dragonfly

Naeemah Pitts, Age 31, Mental Health Worker

"There is no place for innocence on the battlefield."
—JOYCELYN MURRAY

How do you explain to a three-year-old why her parents are gone for months at a time? My father was absent due to drug addiction, and my mother was hospitalized due to her paranoid schizophrenia. I can remember far back the times my mother talked repetitively like a robot and just rocked. I had two older siblings, just by a couple of years. On many occasions, one of them would call a family member and say, "Mom isn't right," and then they would take her away to some hospital, sometimes for as long as two months. I can count eight times this occurred between ages three and fourteen. It was just too hard for my

mother to be a real mother to us. Once I got hurt and she took me to the hospital just like a real mother should, but when we arrived her erratic behavior started, and she became the patient instead of me. She cried because she could not be the mother she wished to be.

Through it all, we kids stuck together: we were not going to be taken to any foster home or other placement. Even without parents, we needed the stability of our own home. So many relatives came and went bringing groceries, telling us kids what to do and when to do it; they meant well, but they broke up our sense of calm and invaded our privacy. But Aunt

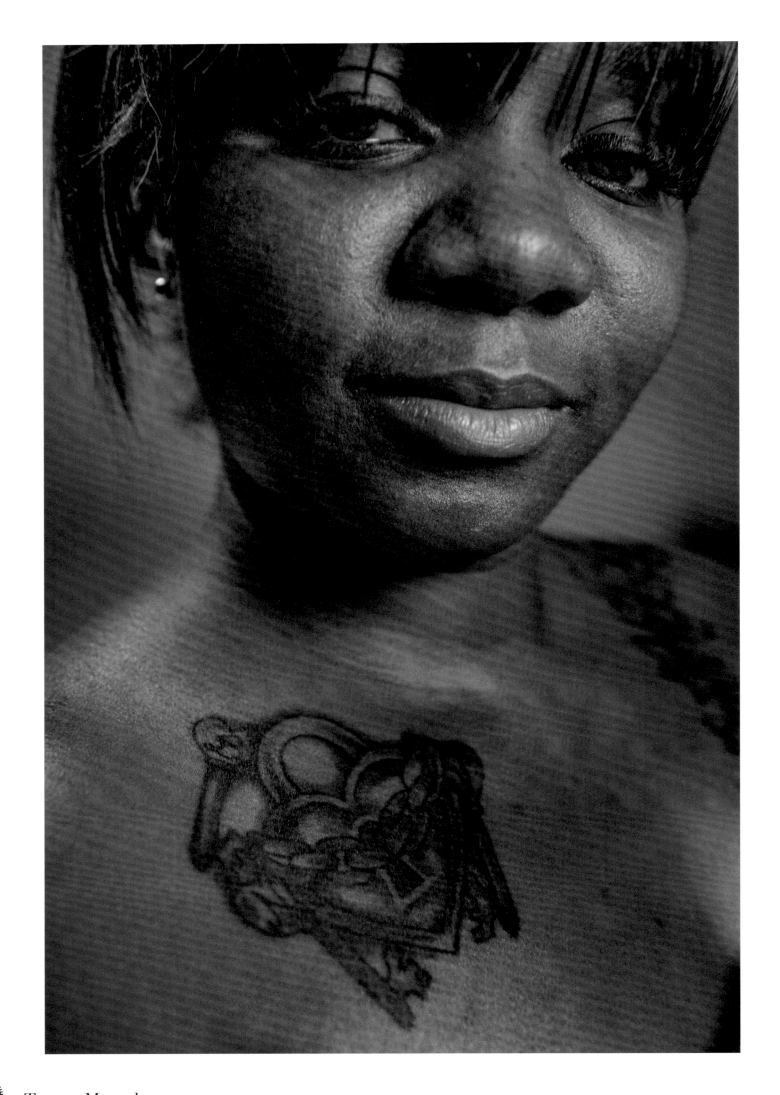

Tattoo Monologues

Margie, a police officer, was different, and she allowed some semblance of control. She made sure we had food, our homework was done, bills were paid, and that we got to school.

As the youngest of the three children, I was closest to my mother. As the "little mother of the house," I emulated her most. Once I was convinced that I could help my mother get better if only I could get her to go to church, but that backfired and worsened her paranoia. We all still remember at age eight, during a long parental absence, when I removed three pieces of chicken from the freezer, one for each of us kids. I cleaned them, seasoned them, and then deep fried them just like I had seen my mom do. I felt grown up at that moment and that I could do anything. It seems so much of my childhood was taken from me.

At age fourteen, I helped my older sister care for her child, who had special needs. It was then that I knew I wanted to be someone who helped care for others. Today, I work with people with mental health disabilities. I want to help people overcome obstacles and support them in areas where they cannot help themselves. I listen to my patients and I meet them where they are. If they are low, I will get low with them, and together we will work our way up. A licensed practical nurse, I will soon complete my bachelor's in social work, then go on to graduate school for a master's. The pain still lurks inside me somewhere and when it emerges, I can feel hopeless. On every such occurrence, a dragonfly appears before me. This graceful, flickering insect is one of my many tattoos and brings me hope. Most precious to me is my son's name on the back of my neck, and my parents' initials behind my ears. In this way I keep them close to me; perhaps it makes up for the long periods of absence when I needed them the most.

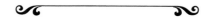

Naeemah is another example of making a career choice, social work, to work out unresolved emotional pain that emanated from childhood. What is interesting is that Naeemah selected a tattoo of a dragonfly because it brings her hope. As far back as Chinese folklore, the dragonfly has symbolized good luck and is believed to bring good fortune to whomever it chooses to land upon. Tattooing the image of a dragonfly is therefore an eternal sign of renewal, a positive life force and the sense of self that comes with maturity. Also, as a creature of the wind, the dragonfly represents flexibility in that it has the ability to change directions when needed. Flying always represents freedom as well as an easy spirit. Dragonflies are incredibly decisive and buoyant in their flying ability, which projects peacefulness, a liberated carefreeness, and a comfort within nature and oneself.

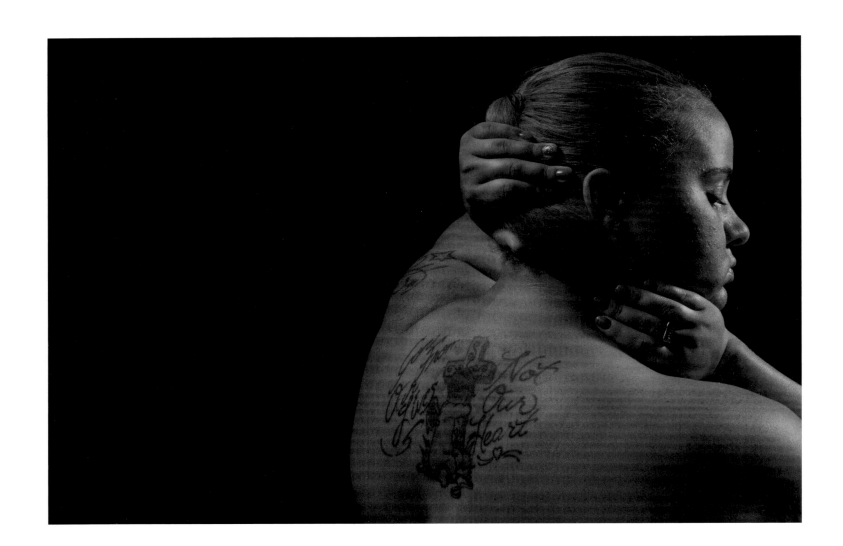

Forgiveness

Phateema Harris, Age 26, Lifeguard

"Forgiveness is giving up the hope that the past could have been any different, it's accepting
the past for what it was, and using this moment and this time to help yourself move forward."

—OPRAH WINFREY

I am a mother of two boys and a lifeguard at LA Fitness. Raised mostly by my mother, my father was in and out of our lives until I was nine. He and my mother separated when I was young. When he returned, we spent a lot of time with him on a farm in Gettysburg. He worked for the local pastor, caring for the land and the church. I loved animals and it was here that I learned from my father how to raise them. I fed the animals, milked the cows, and cared for the ostriches. I even learned how to nurture and ride a partially blind horse.

My father was a lot of fun, taking us on picnics and to historic sites in Philadelphia. I knew he loved me. He was barely back in my life when I lost him at age twelve. My father drank, and heavily. He also took drugs. One night he and I had a fight, and I went to bed angry at him. It was this night he suffered a loss of oxygen to his brain and he passed. I continue to carry great sorrow and regrets about my dad. If only our last interaction had not been one of anger. And if only I had asked him to stop drinking; I believe if I had that he would

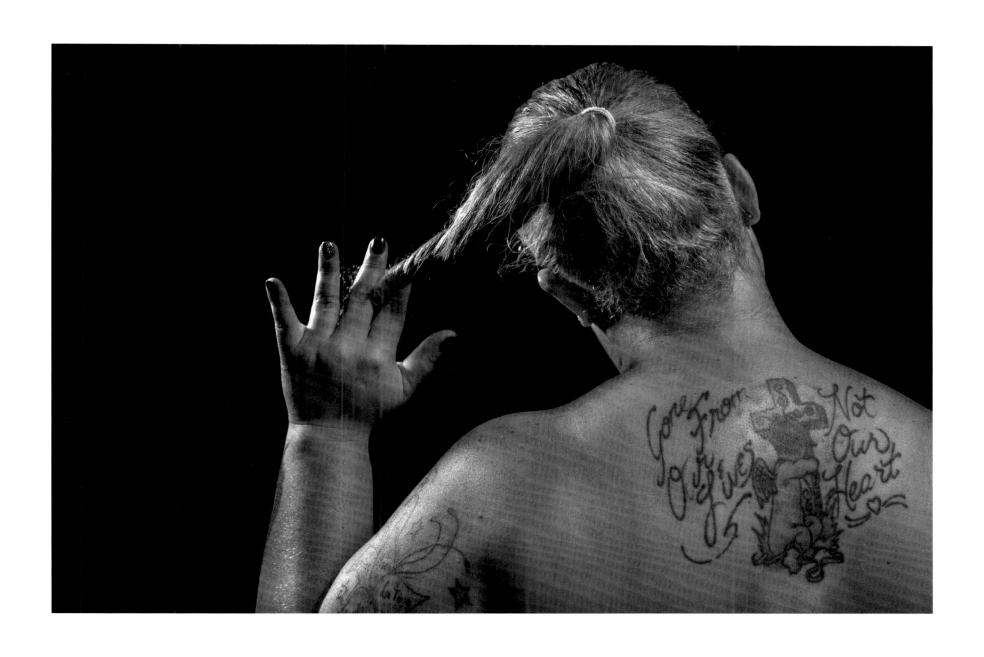

have stopped for me. So, I continue to blame myself for his death. I keep trying to believe that he is in a better place. Perhaps it helps me feel less guilt and shame.

The tribute etched into my back, "gone from our lives not our heart," embraces my dad, my uncle, a second father to me, and my grandparents, cousins, and friends who have passed. An angel hugging a cross signifies that they are gone from our lives, but not our hearts. Now that they are forever on me, I know they are always with me. My family means everything to me. I also carry my siblings and my two boys. I know the body is supposed to be pure, and some people believe that tattoos are wrong, but I love body art and will continue to cherish the symbols on my body that connect me to family who are living and those who are gone.

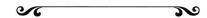

Often it is easier to forgive someone else than to forgive ourselves. When we try to forgive ourselves, it means we are giving up a part of us. When we forgive someone else, we are giving up an incident or event in the past; that is much easier to give up because it is not intrinsically who we are. If by chance the person requiring forgiveness is someone we love (in Phateema's case, her father), it makes it all the easier to forgive. We hold dear our loved one's goodness and our endearing relationship with that person. Yet, many of us have difficulty loving ourselves and therefore self-forgiveness is harder.

It is easier for Phateema to cut her father a break. By doing so, she avoids internal conflict or a rupture in the relationship. However, if Phateema continues to be unforgiving with herself, she can't just walk away. She must live with herself. We first must work on loving ourselves, and the forgiveness will take care of itself.

Pink Dress

Rebecca Smith, Age 47, Homemaker

"A mother's love is forever; time, distance, hardship all fall
before the strength of her love."

—Author unknown

I held her until she took her last breath. Le'Sean Thompson was born at four months gestation and lived six hours. The doctors said her lungs were not developed, but she had everything, even hair, it was just weak lungs. Today maybe they could have done something for her, but that was twenty-eight years ago. We had a funeral with my family all present; my father picked out baby doll clothes, a pink dress, and a white headband. I used to talk to her and tell her I loved her, how much I wanted her to be here, and that I missed her.

Grieving was difficult; it was hard to get myself right. I stayed secluded for about two years, overwhelmed by sadness. I didn't want to be bothered with people, especially children. That was unusual for me because I love kids. But I made it through. My first tattoo was her name; I was scared but I knew I would do it. Having her name on my body, I feel close to her. I know I will never see her again, but she is always with me. There is a connection, a comfort. I kept all her little things in a box, but we lost it all in a house fire. Now, this tattoo is all I have left of her.

I do think about what she would be like today, and how she would look, and I know she could not be the kind of girl people say negative things about like "girls today" She would be my child and she would be a good girl. I inherited a stepdaughter

who lost her own mother at sixteen. She latched on to me and she and her two children stayed with me for five years. She looks a lot like how I would picture my daughter would look today. My family says, "God sent you a daughter in another form."

I have two grown sons now. For a couple of years it had been difficult to get pregnant again, and when I did, I was very frightened. I must have gone to the emergency room every month because I thought something was wrong each time I felt a pain. But they are doing well, and they are good boys. We are a family. All is well.

Getting a tattoo is a commitment—for most people a permanent commitment. You can lose material possessions, but the tattoo will stay with you as long as you have your skin. It is the marriage of ink with your skin; it goes so deep that it is hard to remove. That is the commitment Rebecca had with her daughter; Rebecca will be close to her daughter for the rest of her days on Earth. Little Le'Sean only lived six hours, but her mother's love is forever.

Tic Tac

<center>◆</center>

Sara Woric, Age 28, Physician Assistant

"The anorectic operates under the astounding illusion that she can escape the flesh, and, by association, the realm of emotions."

—MARYA HORNBACHER

It started between my sophomore and junior year of college; it was a control thing, how much could I exercise and how little could I eat. As the disorder got worse, it replaced relationships with friends, roommates, and even my sister. If I went out with my college friends to eat or drink, the next day I would need to make up for it by not eating or by exercising more. I ran thirteen miles a day. It got to a point where I was at the gym at 5:00 a.m. when it opened. What college kid is up at that hour?

As my college friends noticed something was amiss, instead of helping, they put more tension on our relationship. One day I found the word "Psycho" written on my bread bag in indelible magic marker. I can remember feeling so uncomfortable coming home to my apartment that I would sit outside in my car and cry. I learned that I could not control the behavior of others, but I could control my own eating and exercise. I really don't recall ever thinking I was too fat, but instead I focused on how low I could get the number on the scale and how much exercise I could endure. I weighed and measured everything I ate, even the number of calories

in a Tic Tac. In my senior year of college, at 104 pounds and five feet six inches, I had reached my lowest weight and my lowest point mentally. I became hysterical one day during a tense fight with my sister and locked her out of the house. It was then that my father asked if I thought I had an eating disorder.

Today, one of the anniversaries I celebrate is the day I admitted out loud that I needed help. Ultimately, I was admitted to a lockdown unit at the University of Pittsburgh where we were not even allowed laces in our shoes, strings in our sweatpants, aerosols, or razors; I was terrified. I dropped out of college and had to postpone graduate school. For three weeks of my inpatient stay, my parents visited me every day. During inpatient refeeding, we ate every two hours. Though this caused anxiety, it was also liberating as I am the kind of person who likes to follow rules. My type A personality drives me to be the best that I can be, so I had to be number one in the class of recovery. Because eating disorders are associated with the highest morbidity of almost any psychiatric disorder, we were watched closely, even to the point of having

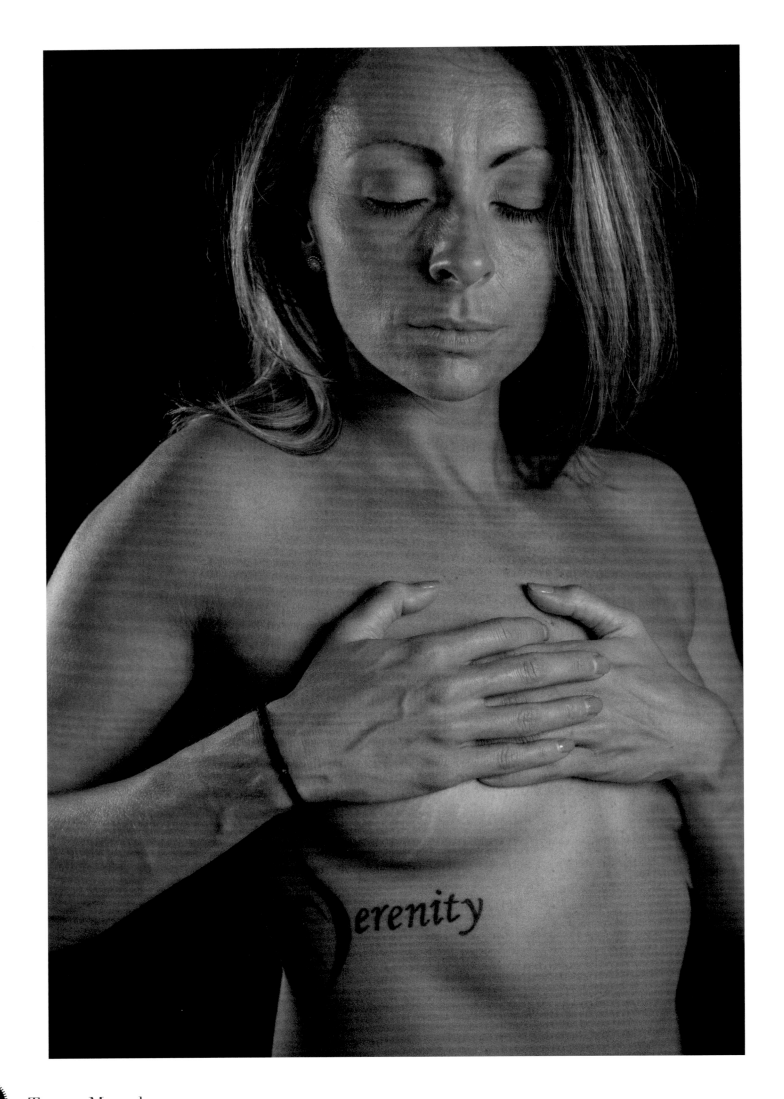

Tattoo Monologues

our bathroom activities monitored. My inpatient stay was followed by thirty-six hours a week of intensive outpatient treatment and then a night program.

Today, I am more aware of how far I have come than how far I have to go. Several years after the onset of my recovery, I decided I wanted the word "Serenity" tattooed on me. We recited the serenity prayer daily during our recovery. This prayer continues to resonate with me and sits on my wall. I have had to change the way I look at things: nothing is black and white, and there are many shades of gray.

I am in my fifth year post recovery. I don't know why but it feels different. I am in such a good place and I want to share it. I want to encourage others and give them hope. I understand that it does suck to be in the midst of such pain, and it is the hardest thing that someone afflicted with this disorder will ever have to brave. If I can share my story, I can't hide from it and it keeps me accountable to myself and to others. Sharing is power, and helping someone else means my whole recovery has not been in vain. In some ways, it is like paying forward for someone who needs it. This week is eating disorders week. The painful parts are mostly behind me now, and I will never let myself get to that place again. The "S" in my tattoo was created into the symbol for serenity.

<u>Serenity Prayer</u>

"God grant me the serenity to accept the things I cannot change, the courage to change the things I can, and the wisdom to know the difference, just for today."

Controlling food intake and focusing on the numbers on the scale are very disempowering. Indeed, nothing changes but numbers on the scale. Paradoxically, this demonstrative quest for control leaves Sara with the eating disorder out of control.

Anorexia and bulimia have little, if anything, to do with food or weight. Years of needs and emotions get suppressed without notice. Thus, the body becomes the canvas that needs; unhappiness, anger, guilt, and an array of emotions are expressed. Controlling the numbers on the scale becomes the focus of the internal struggle to deal with the lack of emotional regulation. Feelings, relationships, and a social life get pushed aside when they interfere with rituals and rigid eating patterns. Isolation and despair become one's only companions. These are symptoms of distress. Compassion is necessary to allow Sara to feel safe enough to face these vulnerable issues and express them directly.

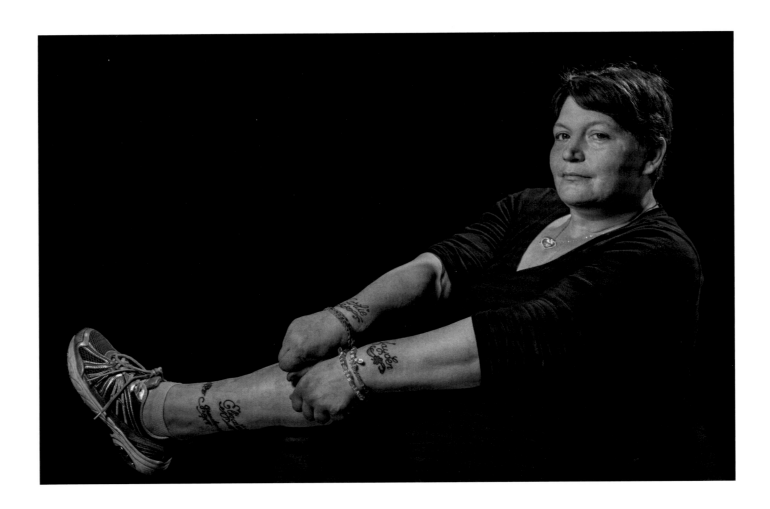

A Nice Ass

---◆---

Stacey Rogers, Age 42, Homemaker

"My trust in a higher power that wants me to survive and
have love in my life is what keeps me moving forward."
—Kenny Loggins

When my grandmother passed away fifteen years ago, I lost my world. She was the biggest part of my life. She was my mother, my father, and my grandparent. She was my best friend most of all. Both my parents were addicts, so she adopted me when I was seven years old. My grandmother was outstanding, very involved politically in the community, outgoing, and very witty. She could make a bad thing into a good thing. Once, when we were coming home from working the polls, I took a bad fall in the street. She said, "Well at least you didn't rip your stockings."

That was her kind of humor. When I hear the song "The Wind Beneath My Wings," which we played at her funeral, it always makes me think of her.

Let me tell you some stories about my grandmother. When I was a teenager, she would allow me to invite my friends over for New Year's Eve, and she would let us drink. Part of the stipulation was that we would all go to midnight mass together. On another occasion, she took me to a Billy Joel concert, and suddenly she stood up on the chair and then turned to me and said, "That Billy Joel got a nice ass."

After she passed, my aunt and I had my grandmother's name in roses tattooed around our ankles. Some people think it's odd, but I talk to her every day. She is my higher power, my god, and my guardian angel. I tell her what I am going through and ask her for help.

My heroin addiction caused a severe bone infection, and I lost my leg. I did not really grieve this loss, and no tattoo is dedicated to this. Becoming an amputee was nothing compared to the loss of my grandmother. I just finished four months in rehabilitation followed by three months in a recovery house. My husband is supportive, but he explained that this is my last chance. I know I have to really stop, or I will end up losing my life or my family. Because of the addiction, I feel guilt and shame every day of my life. My three kids understand that mommy has a problem, and that she is working on it one day at a time. I love my tattoos and when I look at them, I have happy thoughts. They are reminders of what I am grateful for, my family and everyone in my life.

Recovery programs allow you, and you alone, to define who or what your higher power is. Although you may, you need not adopt the view of God held by traditional religions. You can choose to believe in anything that makes sense to you, and which works for you regardless of convention. For some their higher power is nature, for others it is the support of the recovery community, or in Stacey's case, her grandmother.

Your definition of higher power may evolve over time. The higher power is anything that encourages the best part of you to do what is best for you. It gives you courage, strength, and stability. No matter what happens, your higher power will be understanding, loving, and willing to guide you should you lose your way; from this you develop hope, trust, and a sense of being cared for by a power greater than yourself.

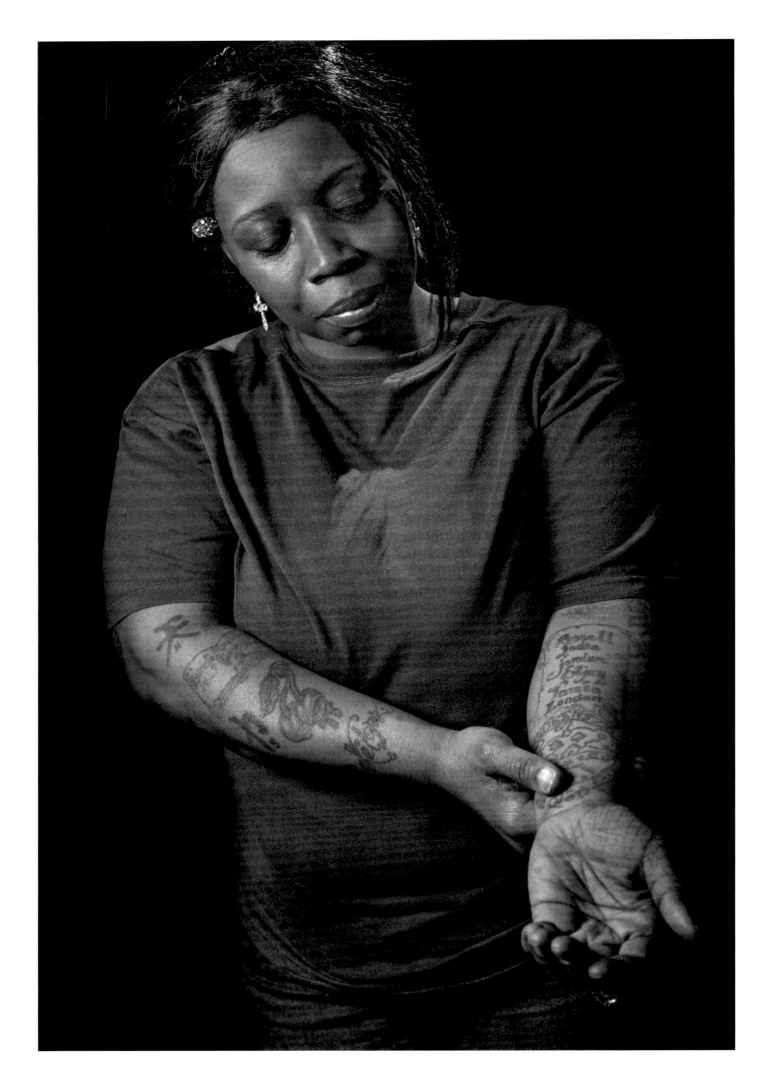

Tattoo Monologues

Motherless

❖

Sylvia McField, Age 39, Uber Driver

"Don't it always seem to go, that you don't know what you got 'til it's gone . . ."
—Joni Mitchell

My grandmother told me it wasn't right to mar, or put holes, in one's body. Contrary to this, she also said the body is only a vessel, and it is the spirit and the soul that move on at the end of the day. I puzzled over this contradiction, and I needed to ink my body; it is what saved me in 2005 when I lost my five children. The police came and took those screaming babies out of my arms. My whole world was gone. It was as if a fire burned in me and I had to find a way to put it out. For several days I was suicidal; I had to get my babies back. I did not even have the pictures or poems that they made for me, not even a blanket, nothing.

I had to have something that no one could take away; I inked my skin with a scroll that contains all their names in order of their birth: Tyrik, Jasmin, Michael, PT, and Lynnae. I did everything to try to get them back—parenting classes, drug tests—but still I only got short, supervised visits. The scroll saved me from my suicidal thoughts, and it gave me strength: it kept the children always with me and continually reminded me that I could not give up. I knew I could not leave them motherless as I had been at age two when my mother died of a heroin overdose. When I would visit my children, they often had flowers for me, even though I did not want a gift that would only die. Instead, one day they made a picture of flowers and asked me to have a tattoo of the picture done so this bouquet would always be with me.

For a long time I was a scared little girl from the projects. I became homeless and drank excessively. I became pregnant and had a stillborn. That nameless little girl held by my mother is inked on my arm, and they both have halos. I left her nameless because I believe my mother will name her in heaven.

Three years later I was able to have my children back. I chose to leave all but my oldest with their foster parents. My life was such a struggle, and I did not want them to suffer by leaving a loving foster family who seemed to have more to offer than I did. Today we are all united, my son is in college and my daughter in North Carolina calls me almost every day and anytime there is something special to share. My bright little six-year-old daughter has always been with me, and she makes me pop buttons with pride. When I ask my son if he hates me for giving him up, he tells me he loves me because what I did was out of love and selflessness. I would not trade anything that has happened to me; I would not want it to have been different, no how. Maybe I had to know that pain to appreciate what I have now.

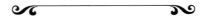

Children who live with one or both parents abusing drugs and/or alcohol often experience an environment fueled by uncertainty and chaos. Children of alcoholic and drug dependent parents often do not experience a predictable and orderly environment that provides them a sense of safety. Parents who are dependent on drugs and/or alcohol often have severe mood swings, creating an uncertain environment. This leaves children uncertain each day if that will be the day there will be an explosive episode. However, this is not necessarily a predictor that these children will end up repeating the cycle of substance abuse or be doomed to unhappy lives.

The children who overcome the difficulties of having an addicted parent often have a guardian angel in the form of a loving grandparent, uncle, neighbor, teacher, or foster parent who provides the security, love, and reassurance they need. These children stand the greatest chance for successful futures. Some continue their healing journey into adulthood by joining Adult Children of Alcoholics, or enter individual therapy. It is always possible to break negative cycles. In Sylvia's case, she was fortunate that her children remained together and were raised by a loving foster family. Fortunately Sylvia, in her sobriety, was able to make a decision that was in the best interest of her children. It is even more fortunate that her children appreciated that decision and forgave her, and they are now a family again.

Huey, Dewey, and Louie

Tracy Zuber, Age 48, Homemaker

"Life is a process of becoming. A combination of states we have to go through. Where people fail is that they wish to elect a state and remain in it. This is a kind of death."

—Anais Nin

I live with my mother, my three daughters, and my grand-daughter. I clean all day and try not to be too erratic. It is an effort for me to experience happiness. Anger seems to be my fallback emotion, and I cannot let it go. I have been diagnosed with PTSD from trauma I have experienced. The trauma was pervasive in my childhood. Then my personal tragedy struck when I lost my young son. Butter (real name Rodney) passed away when he was just three years old. I simply tattooed Butter on my arm. I don't like to think about him being gone. This tattoo is my go-to. Butter was his nickname because he was like a butterball. I think about him every day, and looking at his name inscribed on my arm brings me peace and helps me feel connected to him.

One day he woke up and began to experience seizures. This continued into what turned out to be the longest seven months of my life. He continued to get sicker and deteriorated, and to this day it is unclear to me what took his life those twenty-nine years ago. The only thing I could do was to put his name on me to remember him. He was a bright little boy who loved DuckTales, and on his headstone it says Huey, Dewey, and Louie. I am going to get his portrait on me. No rest in peace, no sunrise, no sunset, just his picture.

For some reason that is not clear to me, I have never, ever dealt with his death. I feel the pain of his loss all over from my heart to my head. I continue to ruminate about whether I could have saved him: "What could I have done, what should I have done?" I know I have never dealt with his loss, but crying is not an option for me because the tears won't come. Instead, I get angry and my rages are a concern to my family. One day I will have a good long cry and my grief will start to fade. Perhaps it is the guilt that keeps me emotionally stagnant. Somewhere I must have failed him. Mothers are supposed to be on top of everything, and I just didn't cut it as his mother. Sometimes I wish for just a second that he could tell me how I let him down.

Butter would be twenty-nine today; he was my second oldest child. I wish I could see how he would look now. Sometimes, I close my eyes real tight and try to get a mental image of him, but all I can see is that three-year-old face.

I also have a snake wrapped around my heart, portraying my anguish. The "E" is for everlasting because I believe my sorrow will continue. I sound hopeless but I really have not given up. Sometimes I wake up and thank God that I am here and for my family and grandchildren. I say to myself, "Tracy, life is a struggle, but you are here, and you are alive, and you are okay." My name on my leg tells me that somewhere inside me, Tracy counts; she belongs here and deserves to be celebrated.

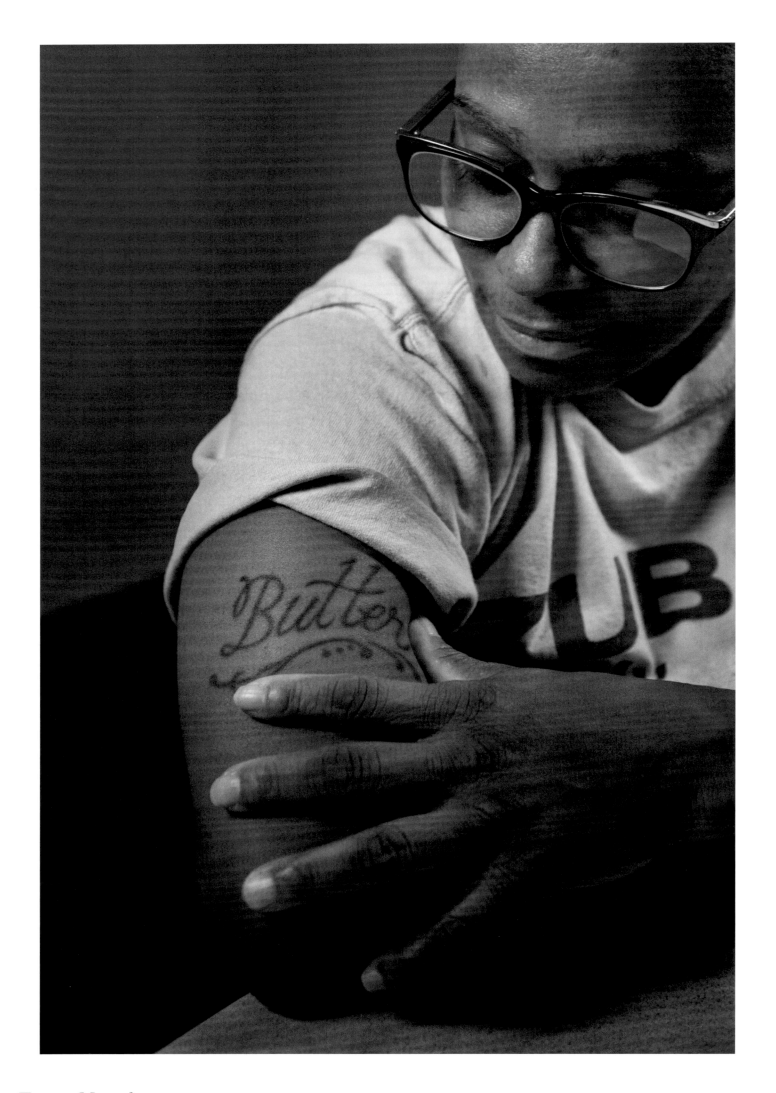

Tattoo Monologues

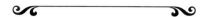

Complicated grief takes place when someone gets stuck in grief. They have difficulty moving beyond the pain of their loss for years and years. Since Elizabeth Kubler-Ross developed the five stages of grief in the late 1990s, our understanding of grief has evolved. These may be the stages of normal grief, but what is the difference with complicated grief? Perhaps in the case of complicated grief, "why" should be added as a stage. "Why" keeps you pondering the past; examining the "What if? Should I have? Why did this happen?" keeps you frozen in time.

The "why" question prevents opportunities for growth or movement toward healing. "Why" can be a powerful question that leads to clarity and progress, but the unanswered "why" leaves Tracy with more questions than comfort. If she is fortunate to get answers, she may finally move on to the final stage of grief—acceptance. If there are no answers, the only choices left are to remain stuck in grief, or to choose to let go and move on.

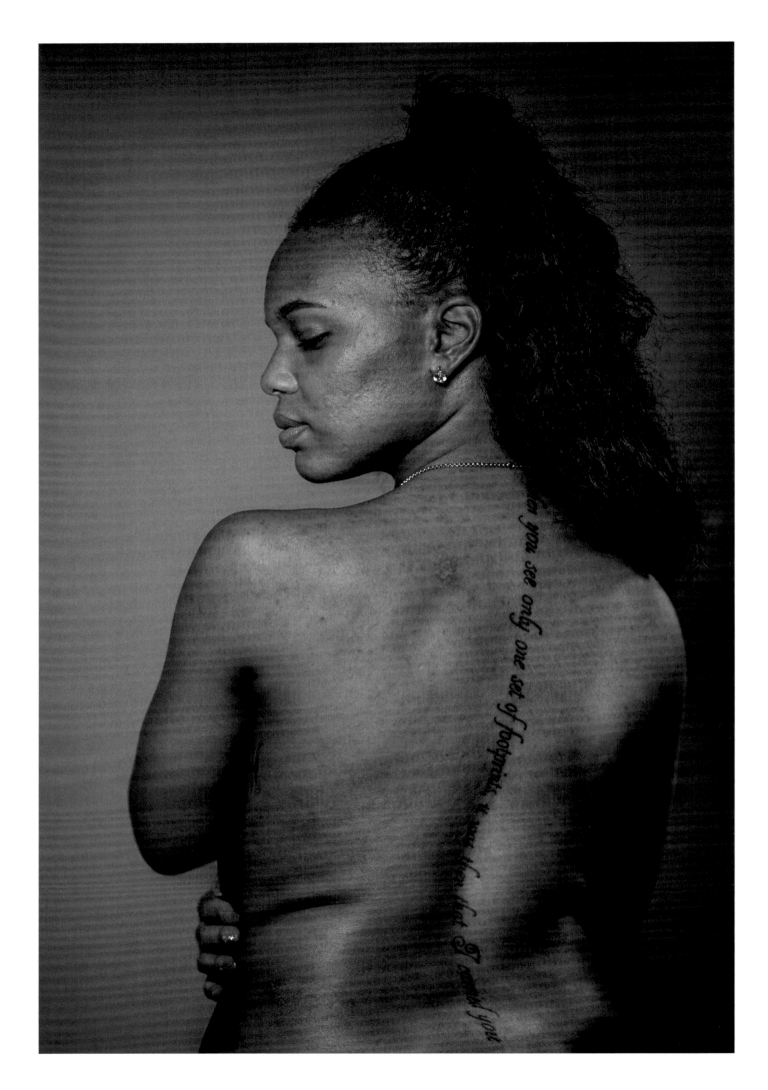

Tattoo Monologues

La Belle La Vie

❖

Turquoise Burton, Age 25, Accountant

"Power is given only to him who dares to stoop and take it . . .
one must have the courage to dare."
—Fyodor Dostoevsky

I was able to keep my first two tattoos hidden from my mother until I had a serious accident and spent several weeks in the intensive care unit. On my right side is a tattoo, *la belle vie*, which means the beautiful life in French. It meant I am free, doing something on my own. Little did I know that my beautiful life would come to a halting and distressful pause in the fall of 2010.

In October of 2010, I was out with a friend headed to a party. The roads were wet, and my car hydroplaned on the highway. Everything seemed fine, and we were just calling for help, and then I awoke in the hospital. On the highway I was hit by a car. My friend did not survive. I was hospitalized and in rehabilitation for several months because of the severe injuries to my legs. I couldn't process what was happening to me. I was unable to speak. A writing board was used to enable communication. There was severe damage to my legs, and I was told I could lose them or may never walk again. I had to get plates and screws and skin grafting.

I am someone who likes getting dressed up, and my goal was to get back into my heels. They laughed at me and said, "You can't even walk right now," but that was my motivation. The loss of my friend was excruciating. I think of her constantly. As the driver of the vehicle, I was responsible for her and was supposed to keep her safe.

My strong Christian upbringing has supported my emotional and physical recovery, and served to strengthen my relationship with God. Despite the repeated claims from doctors that I may never walk again, I listened to God and knew everything was going to be fine. The accident served as a catalyst to strengthen bonds between me and my family and friends. I am back at work full-time, in school, and even wear heels occasionally.

My gratitude inspired my most recent tattoo, which travels down my spine: "When you did not see my footprints, that is when I was carrying you." It is from "Footprints in the Sand." I know that throughout my recovery, God was carrying me.

"Please pray for . . ." is commonly asked when someone goes to the hospital. There are scientific studies that show prayer can have measurable effects on health. Findings indicate that people of (any) faith who pray are able to cope with stress better; they have an elevated sense of well-being; they're more optimistic; they are less depressed and anxious; and they have stronger immune systems, lower blood pressure, and probably better cardiovascular functioning. All religions support the benefit of prayer. The dictionary defines belief as "confidence in the truth or existence of something not immediately susceptible to rigorous proof." Beliefs do not automatically speak for what is true or valid. The belief comes from within the individual believer. But does all this undoubtedly mean that we are communicating with God? For Turquoise that answer would be yes. Yet that interpretation is purely subjective. However, religion provides a belief system that helps people navigate life's challenges. More hope provides a more optimistic attitude and a sense of peace when we have little control over unanswered questions.

For many reasons, however, research on the effects of prayer healing is tainted with assumptions and contradictions that make this debate a scientific and religious minefield. For every research that comes out in support of the positive effects of prayer, an opposing one follows. First of all, we have learned from the placebo effect that just the belief or thought that we are receiving a real prescription drug, which really is a "sugar pill," will cause about a third of us to respond positively. The positive response is not because the sugar pill had healing properties; rather it is a result of the person's belief the placebo had healing properties. It is the mind-body connection that is responsible for the improvement of health. Expectations are powerful. If we think or believe we have been given a drug that will make us better, often that is enough to make it so.

Other studies have found that a positive attitude improves a wide range of health outcomes as well as overall contentment and enjoyment of daily living. Love, support, and positive belief can go a long way. It is undeniable that for Turquoise there is a definite correlation between her relationship with God and her healthy recovery.

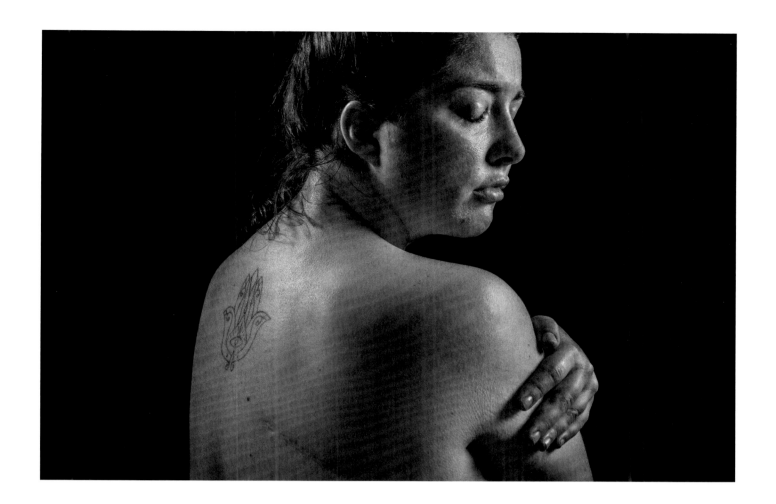

Protection

Christine Torrisi, Age 26, Social Worker

"Personal power is the ability to stand on your own two feet with a smile on your face in the middle of a universe that contains a million ways to crush you."

—J.Z. COLBY

Who has surgery when they are only hours old, ten more operations in the first year of life, and a hysterectomy by age seventeen? In addition, my parents had to perform painful procedures on sensitive parts of my tiny body regularly. I am not sure which of us suffered the greater pain, but I am told my mother cried as she followed the doctor's orders. Internally my organs were just not connected right, and for a while they were not sure I would make it. Following the surgeries, there were plenty of doctor visits. I was a medical anomaly, which made me a spectacle for medical students and residents who gawked at private parts of my body. Though most of this occurred when I was very young, I believe the cells of my body remember the experience, causing me to experience PTSD. It gets stirred up by doctors and hospitals, and it is then that I feel like a vulnerable, raw, and frightened child.

For a long time, it was difficult to accept this body with all its scars. I think of my body as telling a story of the trauma I survived. I could not trust this body that betrayed me so

often. Like Marley the dog who did not survive, I even had surgery for a twisted intestine. Now when I have pain I have to wonder if it is super serious or just something that will pass. I just want to be normal and not worry about interpreting every ache or pain, or whether to make a hospital visit. The theme in my life is that I have limited control over a body that has betrayed me and not given me reason to trust it.

The hamsa is an open hand and a sign of protection that is popular throughout the Middle East and North Africa. I think of the center of my back as a place where a comforting person will pat me and tell me everything is going to be alright. My scars tell me where things went wrong and about my survival, like a tiger who has earned its stripes. The tattoo is a marking that I chose, and it enabled me to reclaim my pain and take control over my body. It put me in charge, something I so seldom experience.

Many children who have chronic health problems feel that they have no power or control over their own lives. Control of your life may have been taken away when you were feeling sick and vulnerable. Family members and friends made decisions and acted on your behalf because you were a minor and couldn't make those decisions for yourself. However, even in adulthood, medical professionals may influence or pressure you to make decisions when you are feeling scared and defenseless. Besides feeling betrayed by your body, you may feel stripped of your power over your body and your choices. Taking back control of your life by making your own decisions and your own choices is essential to mental and physical well-being. It will help you to feel better about yourself. Christine will take back control with the support of the hamsa that will protect her from harm and bring her abundance and good health.

A Daisy Moment

Mamie Guiderra, Age 62, Nurse Midwife and University Faculty

"Be Honest when you are with your kids, because you see
your past in their eyes and they see their future in yours."
—NISHAN PANWAR

It was the last meaningful exchange I really had with my mother. I had ideas of having a tattoo for a long time and just wanted to do it while she was still on this planet. She was unable to speak but when I showed it to her, she gave me that look that said, "I can't believe you did that." I can't believe it either because, when my eighteen-year-old son got his first tattoo, I was so angry, I locked him out of the house. Perhaps I was angry he did it first. In any case, what a turnaround I made!

I was one of ten children, and my mother was the "mom of the world" and Grandma Daisy to twenty-seven grandkids. When the stroke happened in her eightieth year, I just needed to do something to mark this place in time. The ink etched into my right hip, designed by me, serves as that marker. The tattoo artist was tough, which may be an oxymoron. The pain was excruciating and when I asked for a break, she just said, "I told you it would hurt." If I said that to the moms in labor, I would surely get fired.

My mom, Mary, also my namesake, was a great role model for loving, and though I cannot ever remember her saying, "I love you," I just knew she did. She was not someone who had a lot to say, but when she did, it was to call us on the carpet about being persons of integrity or to say something funny. She was someone who had an open attitude of "yes." I once brought forty kids home after a basketball game and she just laughed. She was not a hovering mother and gave us our space to do our own thing.

Grief takes a long time, and as much as you love someone, and you have made peace with their death, there is something deep down that stays for a long time. A simple song, a smell, or a memory can serve as a trigger for the sadness. Mary was a "domestic goddess" who possessed a lot of wisdom. When I had an issue with work I would talk to my father; if it was a subject that pertained to a difficulty with one of my children, it was my mother I needed. I once wrote a letter to one of them to express a strong opinion, something my mother had once done for me after she witnessed an argument I had with one of my sisters. Her letter to me was poignant, a bit of a hand slap asking me to get a grip on myself and demonstrate integrity. My letter to my child was a "Daisy moment"—I was channeling her.

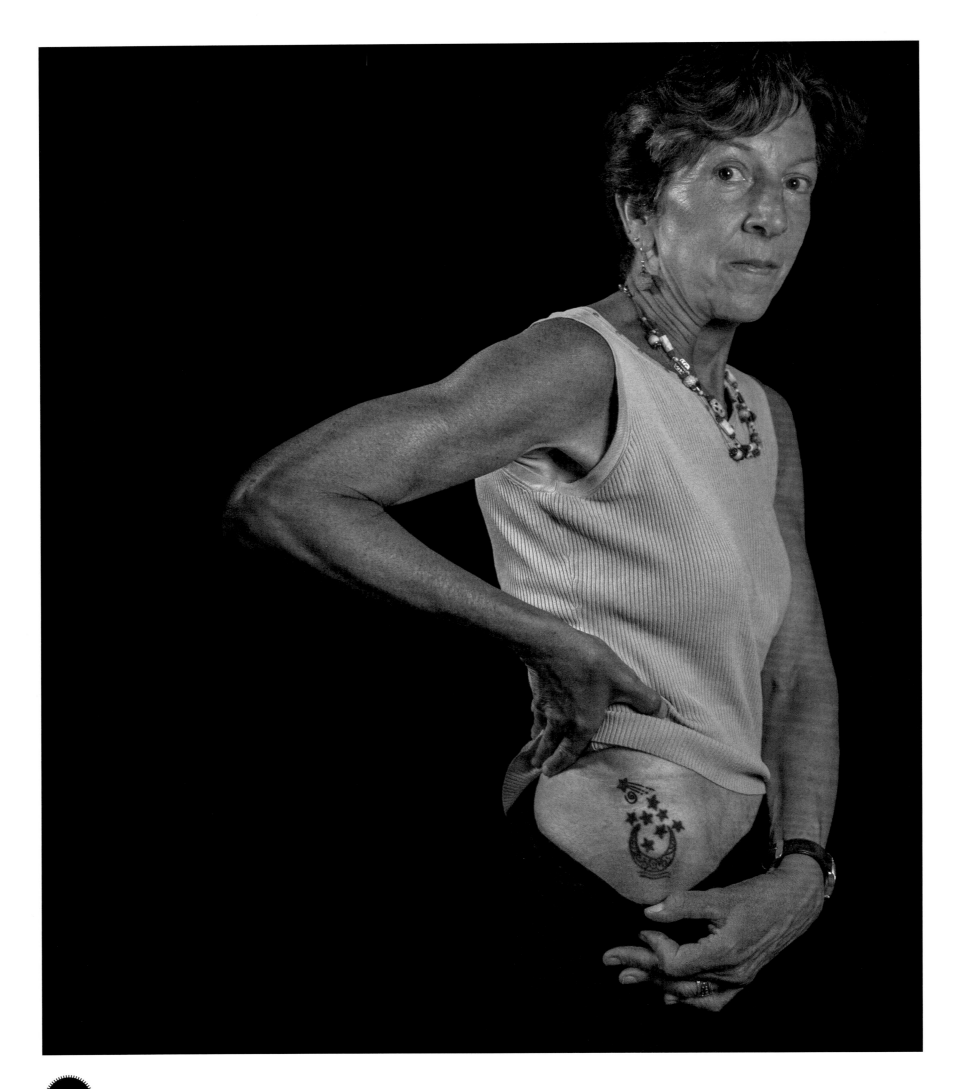

Tattoo Monologues

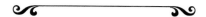

Children can have many role models throughout life, but parents in general, and mothers specifically, are the most significant role models in their development. There are a multitude of concerns and problems that increasingly arise during each stage of a child's development. Parents who are truthful with their children about mistakes they've made and what they learned from them can profoundly impact a child's emotional growth. Parents can offer alternatives and decision-making that they personally experienced as examples. By sharing dilemmas and obstacles in their own lives (such as how they handled being bullied, disputes with a boss or friend, disappointments) in an age-appropriate manner, parents can provide authentic guidance and support for their children to address their problems.

By demonstrating principled behavior, parents can exemplify values that are contrary to what the child may experience from peers or the media. The accountability of being a role model can also embolden a parent to be a better person for their children and themselves. Mamie hopes to replicate her mother's style of mothering. She will do that because she learned from the best— Daisy, her role model.

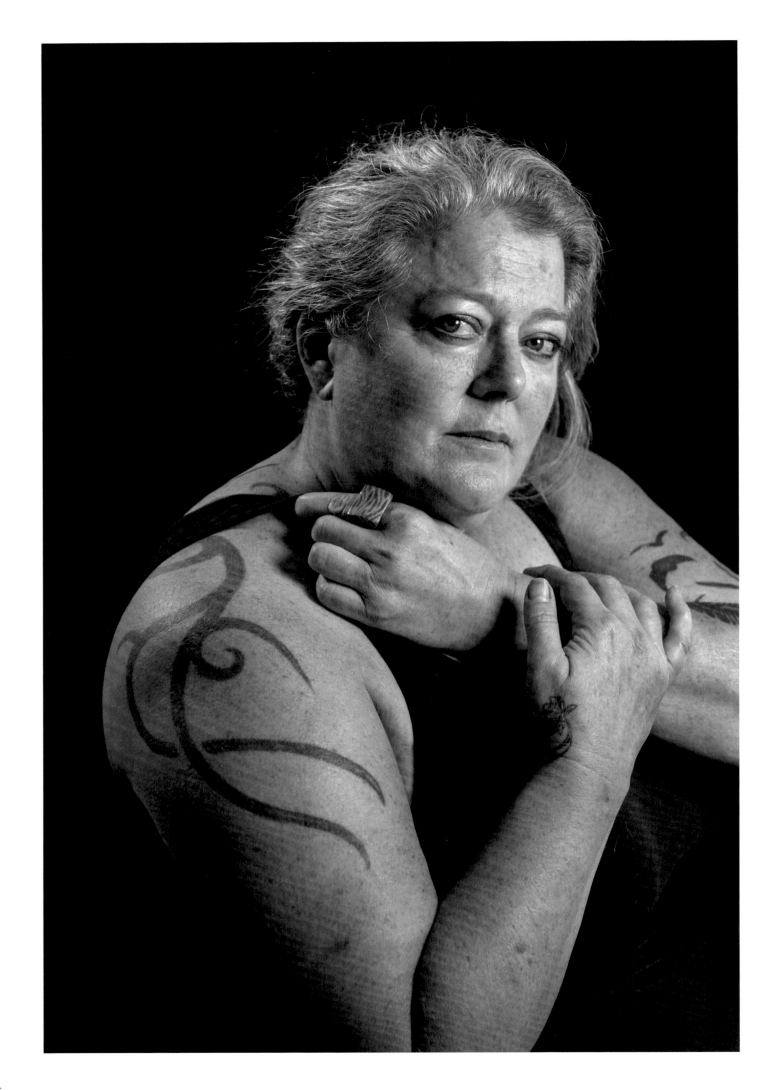

Tattoo Monologues

Abandoned

<center>❖</center>

Karen Smith, Age 52, Psychoanalytic Psychotherapist

"The past does not define you, the present does."
—JILLIAN MICHAELS

I experienced a massive trauma that would occupy my emotional life for the next four years. I had to figure out how to survive it and get connected to my body and my sexual self. I needed to restore hopefulness in my life. My father was in the military, so our family was living in Portugal. I was eighteen and heavily into drugs when I was abducted and raped by multiple men in multiple locations. I was wasted when the assault happened, which was both a blessing and a curse—it helped me to not be fully present during it, but it may not have occurred had the circumstance for me been different. After that I quit drugs cold turkey.

As a Jewish woman, getting a tattoo is complicated, though I needed a violent reclaiming of my physical self. My body had been violently taken from me, and I was going to violently take it back. The fact that the marking of my body was going to hurt was what had to happen. In marking my body myself, I was capturing the energy of my sexual self, the side of me that was strong and aggressive. The tattoo is dark and beautiful, representing not the young and vulnerable girl I was, but rather the potent, strong woman I have become. I don't care much what other people think about it, what is important is that I like it. The tattoo was the beginning of letting go of the assault; it no longer had such an impact on me. It was like writing down something that was on my mind; I could now let go of the thought.

My mother struggled with the tattoo; it was as if I had written on her body. Working this through with her gave us a language for being separate. Actually, my mother is just like me, and at a different age she would have done the same thing. My family had a hard time allowing me to talk about the event. I spent many years traumatizing my family for not being able to deal with my trauma. They could not tolerate thinking about it, and I needed them to. So, although I have forgiven my assailants, it was more difficult to forgive my family. I had to learn how to be kind to the young person in me that was so injured.

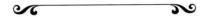

Rape is a trauma. Rape is a devastating trauma. How one faces that crisis can be transformative. For some survivors, the rape is something that happened to them. For others, recovery lasts a lifetime; being a rape survivor can define their being and alter the direction of their lives. For them, rape is internalized and becomes who they are, their identity. In other words, the rape defines them. The victim doesn't necessarily need to resolve the pain or make peace with the trauma, but they do need to regain their power in relation to it, to understand it, to see its impact on their life and their personhood. Karen's story is one of empowerment, insight, and identity.

Baring My Chest

Sylvia Metzler, Age 80, Retired Nurse Practitioner/Social Activist

"Life holds potential meaning under any conditions
even the most miserable ones."
—DR. VIKTOR FRANKL

Perhaps I was dreaming about it, or somewhere it played in my subconscious, but all I can tell you is that I woke up shivering. It was two days before I was to have the bilateral breast reconstruction. Something told me not to do it. Maybe it was my age—I was now seventy-eight—the longer time under anesthesia, or my fear of surgical complications, but it was clear to me that I wasn't going to do it.

I always wondered if someday I might get cancer; it was so prevalent in my family, and even my daughter had breast cancer. That did not lessen the shock, the fear, or the sadness that shot through me when the doctor called to tell me the results of my breast biopsy. I was attending a political meeting at the time, and was surprised that the news would be delivered via phone call. Though the men with whom I shared the news could not have been more caring and kind, I found I longed for the presence of a female who might understand more what it was like taking in this unwelcome information. So many things raced through my mind: surgery, radiation, chemo, hair loss, and the thought that I was not ready to die. There was still so much to be done.

I chose to have both breasts removed to eliminate the chance that cancer would occur in the spared breast. Though an infection followed the surgery, I never wanted for support in the form of visitors, home cooked meals, and medical care.

When I dressed, the reflection in the mirror saddened me as I felt the loss of the breasts that had been a part of me for seventy-seven years. I am not sure how the idea of a tattoo occurred, but I found myself imagining what it might be like to cover my chest with art, something that was meaningful. I am an avid environmentalist, fearful that if we do not take care of Mother Earth, we will lose our pollinators and food will become scarce.

The tattoo that now covers my chest, a vine of flowers with a butterfly and bumblebee, is more than a pretty picture. It speaks to my beliefs and to my heart about my love of the earth and concern for future generations. I have used it to tell a story and convey a message. I once dressed as a bee and met with children at camp to talk about pollination, and how this related to the production of food. On Earth Day, I sat outside Home Depot and protested the selling of destructive pesticides. Most fun was running a five kilometer race, and as I crossed the finish line, I tore off my shirt, arms raised victoriously in the air.

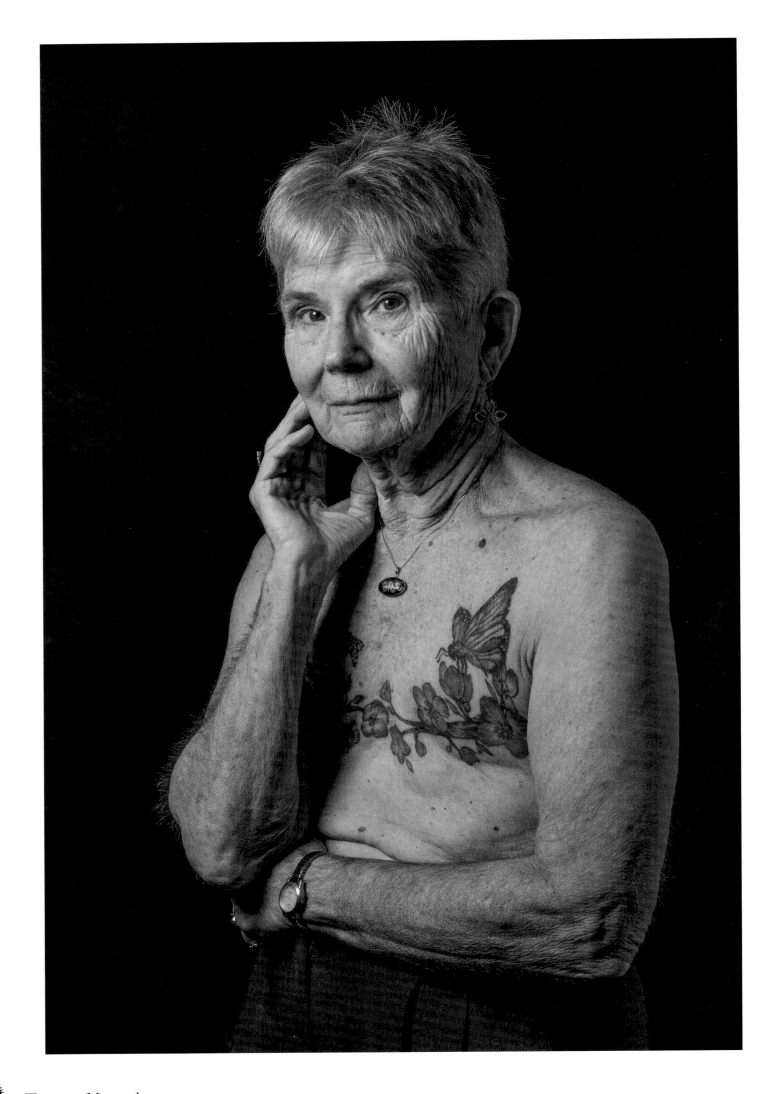

Tattoo Monologues

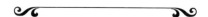

When asked about the juxtaposition between a life-threatening illness and a life-affirming tattoo across her chest, Sylvia merely shrugged, although the connection resonated with the interviewer. Sylvia's story is about grieving the loss of health and a physical part of her body. However, that is not the end of her story. There is an enduring impression when one faces death; it includes an array of emotions. How much does one allow themselves to feel or not feel?

Adaptive coping mechanisms help individuals face these difficult times. But after the immediate danger passes, the journey of healing physically and emotionally begins. Very often human nature yearns for meaning. How can I understand this calamitous, potentially deadly incident? And if I can't understand it, then what?

For some, the trauma leaves an indelible mark, and the pain and suffering linger. Simply surviving the traumatic crisis does not guarantee that one will become a stronger person for it. Yet, reports of growth following traumatic experiences far outweigh reports of chronic distress. Many experience a greater appreciation of life, renewed hope, and engagement in life. Sylvia's passion and commitment to protecting the environment for her loved ones and future generations were not only strengthened since her trauma, but artistically imbued on the canvas of her body, and empowered by the beating of her heart.

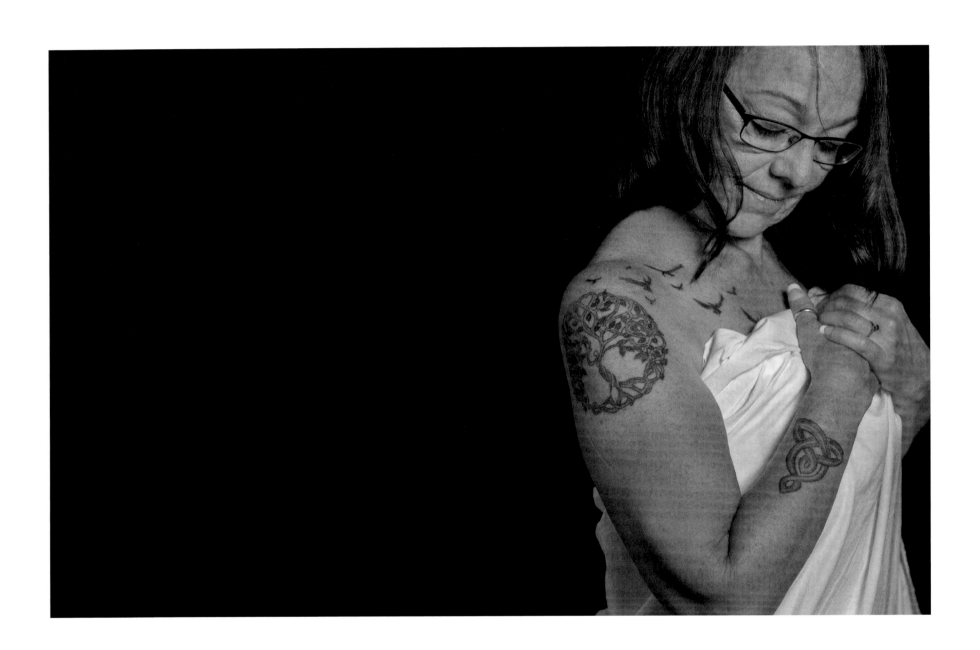

Tattoo Monologues

Engraved on God's Hands

— ◆ —

Jennifer Digges, Age 51, Certified Nursing Assistant

"What is due me is in the Lord's hand and my reward is with my God . . ."
—ISAIAH 49

Despite some religious objections to tattoos, I believe quite to the contrary that God has all his children engraved on the palms of his hands. "Strength was created in me through all the madness I survived" is the tattoo that runs the length of my spine.

I had been sick with strep throat for a week. When my stepmother insisted on taking me to the doctor, I knew my secret would be revealed. It had been five and a half months, and I had only told my Aunt Marilyn. "Did you know you were pregnant?" asked the doctor. Several hours later I was facing my father, terrified. At seventeen, I was still in school, we lived in the South, and my baby would be biracial. My father was a miserable, angry, and hateful man who took his misery out on us kids with harsh and frequent whoopings accompanied by mean expletives. "Get an abortion or get out of the house," he bellowed. "And is the father that n___er?" I also had no support with a passive stepmother. My real mom died when I was eighteen months old.

I felt shamed, disowned, frightened, and lost. This was my baby and I knew I couldn't kill it. I did not last long in the Catholic Charities home for unwed mothers after I cussed at the nun who told me I would never see or hold my baby following the birth. I shouted: "It's not your baby, it's my baby, and I'll be dammed if I will let you tell me what I am going to do." My father took me to court, and I was sent to a state home. I am not sure what happened next but somehow, I found my way to Chosen Children, an adoption agency nearby in Louisville. I loved my baby but I knew I could not take care of him. At Chosen Children I was treated with kindness and assured I would receive regular letters and photos of a little boy who would be named Ben and raised by two women in Philadelphia.

Following the birth, for a long time I felt empty, angry, lost, betrayed, and even suicidal. I would pray to God to take care of my son and bring him back to me. Looking at the sky, I knew he was under the stars somewhere.

It would be nineteen years before I received the call from Pat Dorner, a licensed social worker and an adoptive parent herself. She created reunions for adoptive families. "I am looking for Jennifer Mackin," were the words coming from the phone, "You have a son who would like to be in touch with you." I can only remember screaming and repeating, "When, when can I see him?" Following several phone calls with Ben, his parents, and our counselor Pat, I found myself

finally boarding a plane for the first time and heading for Philadelphia to meet Ben and his family. Frightened of flying, frightened of what the reunion would bring, I kept telling myself that I had to face my fears and follow my heart. It was a miracle for me. The chances of us ever finding each other made this a miracle. In that big old airport, I was afraid I would not recognize him, but the moment I saw him, I knew it was him. He had two dozen roses for me and I felt comforted, loved, and accepted right off the bat.

Now each time we see each other, we set a new milestone for the next time. Once when we were ending a visit, we talked about getting a matching tattoo the next time. After sending photos of tattoos back and forth, some too feminine for him, others too masculine for me, we settled on one that resonated for both of us. The Celtic symbol on each of our arms represents an unbreakable bond. It is a mother on the outside holding her child. Right now, I am filled with joy that my son is about to become a father, but sad that I am so far away.

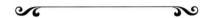

The birth and relinquishing of a baby carries all the pain and anguish of losing a child to death, but this type of loss is distinctly different. The death of a baby is accompanied by acknowledgment, rituals, and support from loved ones to help the grieving mother. On the contrary, giving a baby up for adoption is more often met with secrecy and denial rather than acknowledgment and support. Placing a child for adoption may also cause secondary losses such as estrangement with friends and family.

Being a mother without a child can awaken a sense of incompleteness. There are few role models for birth mothers to help them deal with these issues. Even "voluntarily surrendering" a baby can often feel coerced by familial, social, and/or financial pressures beyond the birth mother's control. Like Jennifer, the majority of women report no diminution of their sadness, anger, and guilt over the many years that elapse after the abnegation of their child. Indeed, many report an intensification of these feelings, especially anger. For birth mothers, the loss of their child may constitute a lifelong trauma. For Jennifer, her tattoo represents the resolution of this trauma.

Teardrops

Eric Amicone, Tattoo Artist

"Doing the right thing for someone else was like a tonic for me;
it was like some magic ointment that made a wound disappear."
—Susie Bright

Sometimes I have to cut a long session short and go for a walk and get my thoughts together because the stories women tell me are so difficult. I am like the bartender; sometimes my customers need an ear and that is something I can provide. I don't give them advice or preach that "Everything will be alright." I have learned the best thing to do is to listen. As a thank you I have received gifts from women and emails that say, "I will be there to see you soon, I need my therapy." As someone on the outside of their lives, customers often feel more comfortable opening up to me. I tell each customer whatever is said here stays here, so there is an assurance of confidentiality. I try to honor women by remembering the stories they tell me. I make sure not to touch on anything too personal that they might not want to talk about; I leave it to my customer to decide what to share and at what point.

Once I had a woman ask me to cover up scars on her abdomen caused by an injury when her ex threw acid at her. After three long sessions, she was pleased with the colorful bouquet of flowers on her abdomen. Three weeks later a younger woman came in with a similar type of scar also

asking for help with a cover-up. I learned during our first session that she was the child in the arms of the mother and that they had endured the same tragedy. That gave me chills. Sometimes the physical scar is so small I can barely see it, and I realize it is the emotional scar that is the true burden for the woman. Sometimes, during the tattoo process, a woman might become emotional to the point of tears. This is painful for me, but I receive solace in knowing that I am assisting her in the creation of a new beginning.

There have been times that I have refused to place tattoos when I believed the placement might result in hurting a woman's career or causing her to be judged negatively. For example, a customer, Kim, whom I had known since she was sixteen, asked that I place a teardrop on her face following the sudden and tragic death of her little sister. I refused, knowing that she might later regret it. Ultimately, she expressed gratitude for my counsel. On the other hand, a teenage girl had some nasty words for me when I turned down her request for a neck tattoo. Her parents were grateful for my position. An artist should point their customer in the right direction. Doing the right thing always trumps putting a few dollars in my pocket. I treat women in the manner I would want my wife or my daughters treated. If I did anything else, it would be difficult to live with myself.

Job satisfaction is like a revolving door. The greater the satisfaction, the better the performance; the better the performance, the better the feedback; the better the feedback, the greater the performance and satisfaction. Besides the artistry, Eric enjoys the intimacy of the relationships that he has with his clients. He gets satisfaction from being part of someone's healing process. He values principle over pocketbook. Doing the right thing is not always easy, but for Eric the fact that it is right is motivation enough to do it.

Reference

DeMello, Margo. 2000. *Bodies of Inscription: A Cultural History of the Modern Tattoo Community*. Durham: Duke University Press.

Fosha, Diana. 2006. "Quantum Transformation in Trauma and Treatment: Traversing the Crisis of Healing Change." *Journal of Clinical Psychology 62*(5): 569-583. doi:10.1002/jclp.20249

Fruh, Kyle, and Emily Thomas. 2012. "Tattoo You: Personal Identity in Ink." In *Tattoos—Philosophy for Everyone: I Ink, Therefore I Am,* 1st ed, edited by Robert Arp, 87. New York: John Wiley and Sons.

Groddeck, Georg. 1977. *The Meaning of Illness: Selected Psychoanalytic Writings Including his Correspondence with Sigmund Freud*. New York: International Universities Press.

History of Tattoos. 2019. "Tattoo Statistics—How Many People Have Tattoos?" http://www.historyoftattoos.net/tattoo-facts/tattoo-statistics/.

Kennedy, Bruce. 2010. "In Tattoo Business, Profits are Hardly Skin Deep." *Accessed March 1, 2014.* https://www.nbcnews.com/id/wbna39641413.

Lee, Wendy Lynne. 2012. "Never Merely 'There': Tattooing as a Practice of Writing and a Telling of Stories." In *Tattoos—Philosophy for Everyone: I Ink, Therefore I Am*, edited by Robert Arp, 151-164. Malden: Wiley-Blackwell.

Littell, Amy. 2003. "The Illustrated Self: Construction of Meaning Through Tattoo Images and Their Narratives." PhD diss., Antioch New England Graduate School.

Morgan, Gwenda., and Peter Rushton. 2005. "Visible Bodies: Power, Subordination and Identity in the Eighteenth-Century Atlantic World." *Journal of Social History 39*(1): 39-64. doi:10.1353/jsh.2005.0115

Reyntjens, Kathleen O'Malley. 2001. "Psychological Variables and Personal Meanings for Women Who are Tattooed." PhD diss., Texas Woman's University.

Sanders, Clinton R., and D. Angus Vail. 2008. *Customizing the Body: The Art and Culture of Tattooing*: Philadelphia: Temple University Press.

Sarnecki, Judith Holland. 2001. "Trauma and Tattoo." *Anthropology of Consciousness 12*(2): 35-42. doi:10.1525/ac.2001.12.2.35

Taylor, A. J. 1970. "Tattooing Among Male and Female Offenders of Different Ages in Different Types of Institutions." *Genetic Psychology Monographs 81*: 81-119.

Wallace, Antoinette B. 2013. "Native American Tattooing in the Protohistoric Southeast." In *Drawing with Great Needles: Ancient Tattoo Traditions of North America*, edited by Aaron Deter-Wolf and Carol Diaz-Granados, 1-42. University of Texas Press.

Author's Reflections

Donna L. Torrisi, MSN, John Giugliano, PhD, LCSW, and Ken Kauffman, Photographer

Donna L. Torrisi, MSN

Body art can tell personal stories, and much like talking to a caring individual such as a friend or therapist, when linked to a difficult or traumatic life, it may restore one's sense of well-being. As director of a community health center for twenty-seven years and as a nurse practitioner for over forty years, I became fascinated with my patients' stories behind their tattoos. When I began to ask my female patients about their markings, themes of trauma, pain, and loss emerged and the art indelibly marked on their bodies seemed to play a part in their healing and redemption. Compelled by this theme, I pledged someday I would create a photo storybook bringing these inked narratives to life. My partners, Dr. John Giugliano, LCSW, added a clinical component following each story, and Ken Kauffman, photographer, added the pictorial dimension.

About Donna L. Torrisi, MSN, Author
Network Executive Director, Family Practice & Counseling Network

Donna L. Torrisi, MSN has been a Nurse Practitioner since 1976. In 1992 she founded a Community Health Center in Philadelphia where she continues today to provide primary care to low income communities. It was here that she was inspired by her patients to write this book. The model and her work are recognized nationally and have been the recipient of multiple awards. She is a Fellow in the American Academy of Nursing.

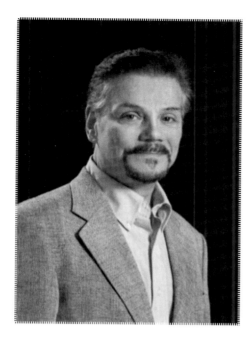

John R. Giugliano, PhD, LCSW

When I was invited to share the authorship of this project, I was captivated. There are many books about tattoos, and even more about trauma, but few, if any, exist about the connection between the two. As a society we can all benefit by understanding how trauma affects the brains of children and progresses to impact mental and physical health into adulthood. With an enhanced understanding of the symptoms and behaviors that result from trauma, we can create a safe and culturally sensitive milieu. Additionally, it enables us to respond in a manner that avoids retraumatization and escalates empathy and compassion. Part of the therapeutic process is telling one's story. In the following pages you will witness these women's stories told in their own way.

About John R. Giugliano, PhD, LCSW, Author

Dr. Giugliano, PhD, LCSW, has a private practice in Bala Cynwyd, PA. He originally started working psychodynamically with people suffering from trauma, mood regulation, and sexuality issues. Dr. Giugliano attended Villanova University, and he received his Master's of Social Welfare from UCLA and his Doctorate from Smith College. Dr. Giugliano was Vice President and President on the Board of Directors of the Society for Advancement for Sexual Health for many years. His leadership in this field has given him national and international notoriety. Dr. Giugliano has presented his work in Europe, Asia, and the US. His research and clinical work are published in scholarly journals and have been translated in five languages.

Ken Kauffman, Photographer

Who among us reveals their deepest pain and anguish, out loud and in public? When one is traumatized, the events and effects commonly remain cloaked in the shadows. Only the most courageous unveil their angst, helping themselves and others in the process. When I was asked by Donna Torrisi to participate in a project about trauma and tattoos, I had no idea I was about to spend time with the bravest people I have ever met. I had never viewed tattoos as the confessional art form that I now know they can be or spent much time thinking about trauma. Tattoos, as I have learned, are so much more than decorative references to relationships, popular culture, or whims, but can be deeply emblazoned mementos of experiences that transform a life forever. Trauma has become a bit more understood by the general public, but remains a phenomenon in need of compassion and care. I have had the honor of being in the company of these extraordinary women who chose to communicate their stories—stories conveying that healing is possible, and that joy and love can be reclaimed in their lives. Thank you to those who have volunteered your histories; your profound sharing has increased the awareness of us all.

In this book, and the film, we bring these stories to life.

About Ken Kauffman, Photographer

Ken Kauffman's ability to decisively capture the serendipitous moments in people's real-life situations has been his specialty for years. Ken has brought the sensitivity and visual language from the genre of "street photography" to his chosen photographic career areas, both fine and commercial art. His ability to connect with people from all walks of life has influenced his work and is the source of his commercial and artistic success. Ken's photographs have been published in many business, health care, and nonprofit web and traditional mediums.

Film created by Ken Kauffman available on the web: tattoomonologues.com

Selected Titles from She Writes Press

She Writes Press is an independent publishing company founded to serve women writers everywhere. Visit us at www.shewritespress.com.

Unfolding in Light: A Sisters' Journey in Photography and Poetry by Joan Scott and Claire Scott. $24.95, 978-1-63152-945-0. An elegant book of photographs, accompanied by poems, that invite readers to discover the beauty, simplicity, and spirituality that flows through hands.

Soul Psalms: Poems by U-Meleni Mhlaba-Adebo. $16.95, 978-1-63152-012-9. A powerful, lyrical collection of poetry that explores themes of identity, family, love, marriage, body image, and self-acceptance through the lens of a cross-cultural experience.

Where Have I Been All My Life? A Journey Toward Love and Wholeness by Cheryl Rice. $16.95, 978-1-63152-917-7. Rice's universally relatable story of how her mother's sudden death launched her on a journey into the deepest parts of grief—and, ultimately, toward love and wholeness.

We Got This: Solo Mom Stories of Grit, Heart, and Humor edited by Marika Lindholm, with Cheryl Dumesnil, Domenica Ruta, and Katherine Shonk. $16.95, 978-1-63152-656-5. Seventy-five solo mom writers—including Amy Poehler, Anne Lamott, and Elizabeth Alexander—tell the truth about their lives: their hopes and fears, their resilience and setbacks, their embarrassments and triumphs.

*She Is Me: How Women Will Save the Worl*d by Lori Sokol, PhD. $16.95, 978-1-63152-715-9. Through interviews with women including Gloria Steinem, Billie Jean King, and Nobel Peace Prize recipient Leymah Gbowee, Sokol demonstrates how many of the traits thought to be typical of women—traits long considered to be soft and weak in our patriarchal culture—are actually proving more effective in transforming lives, securing our planet, and saving the world.

(R)evolution: The Girls Write Now 2016 Anthology by Girls Write Now. $19.95, 978-1-63152-083-9. The next installment in Girls Write Now's award-winning anthology series: a stunning collection of poetry and prose written by young women and their mentors in exploration of the theme of "Revolution."